FOCUS ON
digital portrait photography

FOCUS ON

digital portrait photography

Jenni Bidner

An Imprint of Sterling Publishing Co., Inc.
New York

For more information,
visit our website at www.pixiq.com

Series Art Director: Tom Metcalf
Layout: Jenni Bidner
Cover Designer: Thom Gaines
Production Coordinator: Lance Wille
Editor: Kara Arndt

10 9 8 7 6 5 4 3 2 1

First Edition

Published by Pixiq, an Imprint of
Sterling Publishing Co., Inc.
387 Park Avenue South, New York, N.Y. 10016

Text and Photography © 2011 Jenni Bidner

Distributed in Canada by Sterling Publishing,
c/o Canadian Manda Group, 165 Dufferin Street
Toronto, Ontario, Canada M6K 3H6

Distributed in the United Kingdom by GMC Distribution Services,
Castle Place, 166 High Street, Lewes, East Sussex, England BN7 1XU

Distributed in Australia by Capricorn Link (Australia) Pty Ltd.,
P.O. Box 704, Windsor, NSW 2756 Australia

If you have questions or comments about this book, please contact:
Pixiq
67 Broadway
Asheville, NC 28801
(828) 253-0467

Manufactured in China

ISBN 13: 978-1-4547-0119-4

For information about custom editions, special sales, premium and corporate purchases, please contact Sterling Special Sales Department at 800-805-5489 or specialsales@sterlingpub.com. For information about desk and examination copies available to college and university professors, requests must be submitted to academic@larkbooks.com. Our complete policy can be found at www.larkcrafts.com.

For information about custom editions, special sales, premium and corporate purchases, please contact Sterling Special Sales Department at 800-805-5489 or specialsales@sterlingpub.com.

Contents

Introduction

What Is a Portrait?

Before we jump into a discussion about how to photograph a portrait, I'd like to address an age-old question: "What is a portrait?" The answer to this question is well-known if we consider the classical portrait that painters have been doing for centuries, and photographers since the advent of photography.

This classic portrait has a person or a group of people in a stationary pose looking at the

camera. Though a few daring artists and photographers in the past produced more moody portraits, in which the subject was looking away from the camera, often out a window or into the distance, the basic structure has been defined and followed for a very long time.

Today, however, portraiture is much less limited! Modern cameras allow you to take pictures in almost any situation, including underwater (if you have specialized waterproof camera or housing). Your subject can be moving or still, close or far away, and you can easily shoot from almost any angle.

A modern portrait, as I define it, is any image that tells you something about the person (or people) in the picture. And most modern portraits fall into the categories described on the following pages. When shooting portraits, don't limit yourself to just one or two categories! If you do, you'll be missing out on some of the most creative and rewarding aspects of portrait photography.

One of my favorite types of portraiture bears little resemblance to the classic portrait. It is simply a photojournalistic picture that shows a moment in a person's life. If successful, it can communicate more about the person than a simple head-and-shoulders photo.

An environmental portrait is a variation of the "I Was Here!" Vacation portrait. In this, you show the person's home or work environment, as a way to tell the viewer more about them. The picture then includes a lot of editorial content that tells a story visually. Think of the background and foreground as a way to include clues about the person's identity.

Another category is an unconventional approach that I call alternative portraiture. Most people think a portrait must include the eyes. It can be great fun to experiment in other ways. Ask yourself how many different ways you can tell the story of a person without showing their eyes! If you try to shoot some of these variations, you'll probably come up with a rich group of images that will make your photo album come alive. I've even seen examples that didn't include any portion of the person, but instead was a "still-life" image of items important to the subject.

In future chapters, I will introduce other types of portraits and portraiture techniques, including action portraits, portraits with props, and low-light images. And let's not forget self-portraits.

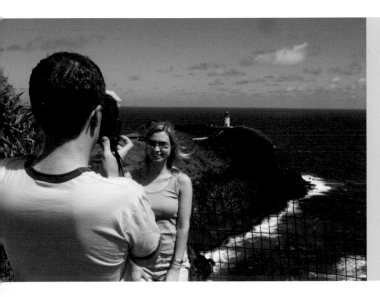

The "I Was Here!" Portrait is a picture where the person and the background are both important. It can be a vacation image in which a scenic vista or important monument is clearly visible behind the person. This kind of portrait is much nicer than a picture of just the scene, because you and companions are included in the picture. It's a great type of portrait to upload to your social networking pages to keep your friends and family updated when traveling.

Photo Fundamentals

If you're new to digital photography or just want to hone your skills, there are several camera functions and photo principles you'll need to learn to be successful at portrait photography. Don't worry—they're not hard! They're just important. But first, take a quick look at the different types of cameras available for your portrait work.

Though manufacturers do make several different styles of digital cameras, most fall into two basic types: point-and-shoot cameras (which include smartphones) and D-SLR cameras. For the most part, the point-and-shoot cameras are compact models popular with most people. D-SLR cameras are generally much larger and more expensive, and cater to the advanced amateur and professional photographer.

Throughout this book, I will refer to camera functions that might not be available on all cameras. For example, the ability to control your aperture is handy in advanced portraiture (see pages 121-125), but this capability is limited to D-SLR cameras and some high-end point-and-shoot cameras. Check your instruction manual to see if your camera offers the various functions described in the book.

1.1 Understanding The Basics

About Your Camera

Tools:

- Holding the camera
- Panning
- Zoom lenses
- Image processing software

Holding Your Camera

The most important factor when holding the camera is to keep it steady while taking a picture. Camera shake can cause blurry pictures, even if your camera has an image stabilization (IS) system.

Start by grasping the grip of your camera with your right hand, putting your index finger on the shutter release button. Use your left hand to cradle the camera's body. If you are using a large D-SLR with a big lens,

put your left hand under the lens instead. Support both elbows by placing them down and in, against your torso. And finally, form a sturdy foundation by placing your feet apart, with one slightly in front of the other.

With many digital cameras, you don't always have to raise the camera to your eye to look through the viewfinder. Most point-and-shoot types and some D-SLR cameras allow you to view the monitor to see what the lens is seeing. This is a big advantage, because you can more easily hold the camera at different angles for creative compositions (see Chapter 3).

Foldout, twistable monitors give you even more versatility, because you can hold the camera over your head or down by your knees and still see the monitor.

Zoom Lenses

Most digital point-and-shoot cameras have a zoom lens that enables you to change the view in a range of increments from wide (W) to telephoto (T). The wide settings show more of the scene in front of you and make your subject look small in the viewfinder. The settings at the telephoto end of the zoom do the opposite. They zoom the lens so the subject is magnified in the picture, looking as though you are using binoculars.

For readers who have a D-SLR camera with interchangeable lenses, take note! You have a tremendous selection of wide, normal, and telephoto lenses to choose from, including some zoom lenses that include it all. The focal length, or focal length range, of the lens determines how wide or telephoto it is. Wide-angle lenses (and zoom range settings on a zoom lens) have focal length numbers that are

low, such as 12mm or 18mm. Telephoto lenses have focal length numbers that are higher, such as 100mm or 200mm. The higher or lower the numbers, the more extreme the effect.

We will go into great detail on focal length selection for portraiture in later chapters. But suffice to say right now, it can make a huge difference in the look and feel of your resulting portraits.

did u know?

When your subject is moving, you'll get the best results if you pan, or move, the camera. To do this, follow the subject in the viewfinder or monitor before, during, and after you click the shutter button. This is called tracking. The more smoothly you do this, and the better your timing, the better your results. To pan smoothly, try to initiate movement from your hips rather than your arms.

Why does panning work? By keeping your subject centered in the viewfinder (and thus in the center of the digital imaging sensor), it is as if they are standing still in the camera. This will help you get sharper pictures of moving subjects—especially if they are moving across your field of vision (such as from left to right).

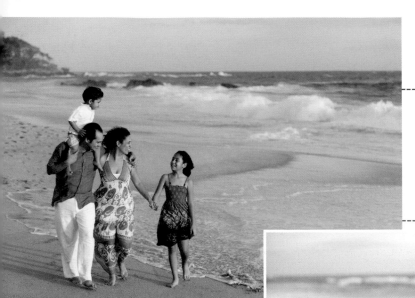

Exposure Mode: Auto
Lens Focal Length:
70mm
Aperture: f/3.2
Shutter Speed: 1/500
Distance: 2m (6 ft)
Metering: Matrix

Exposure Mode: Auto
Lens Focal Length: 70mm
Aperture: f/2.8
Metering: Matrix

Watch out for digital zoom settings. Some cameras offer optical zoom plus an "enhanced" digital zoom range beyond it. It is usually better to turn off the digital zoom and use only the optical zoom. This is because digital zooming degrades the image quality, whereas optical zooming does not.

Focusing Capability

Modern digital cameras have come a long way in terms of focusing capability. They

did u know?
Some cameras are designed to focus on whatever is in the center of the frame when you take the picture. This is great if your subject is centered, but in Chapter 3 I'll show how this is rarely the best composition!

If you find your off-center subject is blurry and the background or foreground is sharp, you'll need to initiate focus lock.

rarely make mistakes on average pictures. And if they do, you can see it when you review the image on the monitor.

However, throughout this book I will be encouraging you to shoot pictures that go far beyond average. You will be taking pictures where the subject is off-center, or even moving. And these factors can affect the camera's ability to focus properly.

Check your instruction manual to see if your camera has center-oriented focusing or multi-segment autofocusing. The former will require you to use focus lock whenever your subject is off-center. The latter will give good results in most situations, but may occasionally require focus lock as well.

Close-Up Photography

Some of the techniques in this book encourage you to get close to your subjects. But watch out! You can sometimes get out-of-focus pictures if you are closer than the lens can focus. On most point-and-shoot cameras, you can get within a foot or two in normal modes, and as close as a few inches in the Close-Up mode (usually indicated by a flower icon). With a D-SLR camera, it depends upon the lens you have attached to the body. Some may not focus closer than six feet, while others are designed for extreme close-up (sometimes called macro) photography.

Exposure Mode: Manual
Lens Focal Length: 100mm Macro
Aperture: f/10
Shutter Speed: 1/125

1.2 Resolution & Size

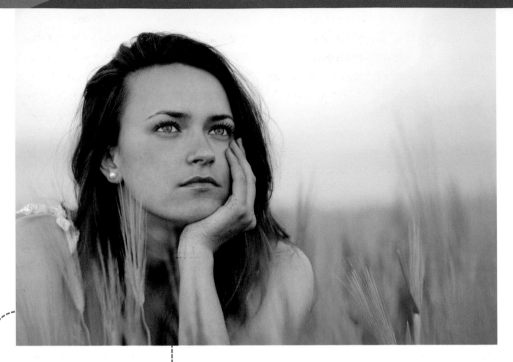

Aperture: f/4.0
Shutter Speed: 1/125
Exposure Compensation: +0.67
White Balance: 6000K

Tools:

- Resolution basics
- RAW or JPEG

Resolution Considerations

It is important to understand resolution. All digital pictures are made up of tiny pixels. The quantity of pixels in the picture determines the resolution of the picture. The more pixels you have, the more detail and clarity any given image will have.

High resolution is important. But how high is high? Most photographers will be very happy with the results they get with a camera that has a resolution range from four to six megapixels, even if they are making large prints. Advanced amateurs and professional photographers may want higher.

Your camera probably has several choices for the resolution or picture size it can record. If you set it to the highest resolution with the highest quality, your results will be the best the camera can deliver. You can print it large, and the quality will be maximized. If you set it to a lower resolution or lower quality (more compressed) setting, you won't be able to enlarge the picture as much, and the quality may suffer.

The only advantage to shooting at a lower resolution and/or a more compressed setting is that you can record and save more pictures on any given memory card or memory stick. High-resolution pictures take up a lot more file space.

My advice is to always shoot at the highest resolution. You never know when that unimportant snapshot might turn into your all-time favorite. If you're worried about running out of memory before you have time to download the pictures to your computer and clear the card—well, buy a second card! They've become inexpensive compared to the prices of a few years ago, so it is a good idea to have a spare card or two.

File Types

There are several different existing formats for recording and saving image files. Digital cameras most commonly use JPEG and, with more advanced cameras, RAW. If your camera is able to record RAW files, it will apply little or no internal processing to them. You can then use software in your computer to read these files and make a wide range of adjustments to the unprocessed data. These are big files that contain at least 12-bit color information and a wide range of data.

JPEG is a standard for compression technology that yields smaller image files than RAW with 8-bit color information. You can usually select a degree of compression, or quality level, that may be found with various names depending on your brand of digital camera. These settings might be labeled something like Fine, Normal, Basic; or Best, Better, Good. The more compression applied to a JPEG file, the smaller it will be (and the less space it will take on your memory card), but the lower its quality.

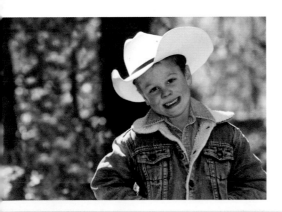

did u know?

RAW is a great choice for the advanced amateur and professional photographer. Special RAW editing software will let you make changes to the picture without affecting the original picture. Most D-SLR cameras and a few high-end point-and-shoot cameras offer the option of shooting RAW images.

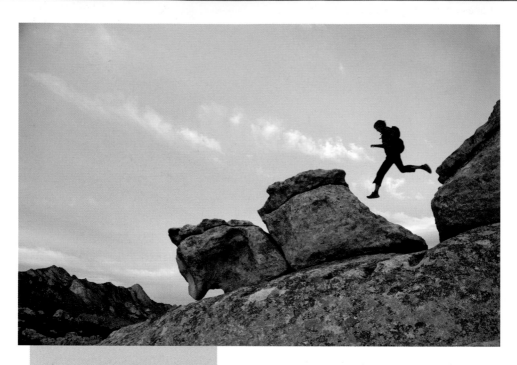

This portrait has both a fast shutter speed to freeze the action, and a high number aperture (such as f/8 or f/11) to get everything sharp from foreground to background.

Tools:

- Auto Program Mode
- Portrait Mode
- Landscape Mode
- Macro Close-Up Mode
- Advanced Modes

Shooting Modes

Some high-end cameras offer other shooting/exposure modes that weight the camera for certain types of subjects. AutoExposure and Program (P) are two modes found on most cameras. They will weight the camera controls for the average subject, and give you good results in many situations. The camera selects all photographic functions when set to AUTO (sometimes signified by a green rectangle or a green camera icon), while Program mode allows the photographer to control some of the settings.

Portrait mode can help improve portraiture pictures by putting the background relatively out of focus. It does not offer the kind of control you can get with the Aperture Priority mode on a D-SLR camera (see page 125), but it does weight the settings toward this effect.

Landscape mode helps by letting you get everything in focus from foreground to background, and is useful if you want your subject and a distant background in focus, such as a scenic travel image.

Sports or Action mode sets the camera so that the shutter speed is as fast as possible for the given ISO setting (see page 131). Surprisingly, it sometimes sets the camera to exposures similar to Portrait mode. So if you don't have a Portrait mode and you do have a Sport or Action mode, try using it.

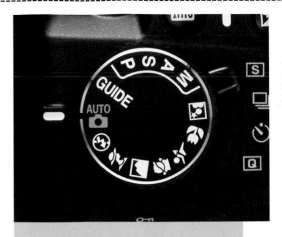

Some cameras have special exposure modes that can help you quickly get the best exposures for certain types of portraits.

Macro or Close-Up mode optimizes the camera for shooting subjects up close. If you are shooting an artistic portrait with just a portion of a person's face, you may want to switch to this mode if you are having difficulty with out-of-focus results using other modes.

Advanced modes enable photographers to select the apertures (f/stops), shutter speeds or both. These advanced exposure modes offer more control over depth of field and subject motion, and are covered in more detail on pages 120-129.

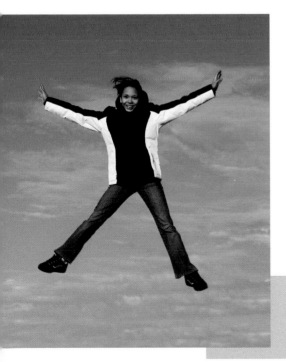

For action-freezing portraits, select Sports Mode, or set your shutter to a fast speed like 1/2000-second.

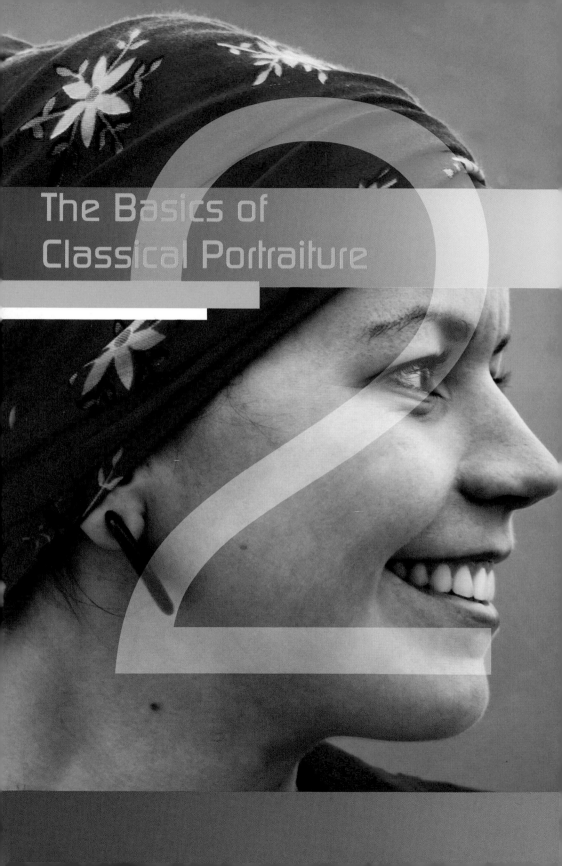

The Basics of
Classical Portraiture

Good news! The quickest ways to improve your photographs are the easiest. Some might seem obvious as you read this book, but until you consciously use them in the field you won't realize their power. Whenever you get a chance, do a "before-and-after" comparison of the technique, because it is simply the best way to learn.

We'll examine those in the next chapter. But let's start by looking at some basic portrait principles that are quick and easy to grasp. These simple ideas will give you a great foundation for shooting the kind of distinctive portraits that will make people take notice of your style. And more good news—many of these same tips will help you improve all your photographs, from scenics to sports.

2

2.1 Portraiture Styles

Candids

I consider candid portraiture to be pictures taken at any time your subject is unaware of the photographic effort, or is so unconcerned by it that they ignore you. This gives you the luxury of playing with your camera controls and experimenting with new techniques without any expectations from the subject.

The easiest way to start is by zooming your camera all the way to the telephoto setting (or switching your D-SLR camera to your lens with the highest number focal length, such as 200mm). Then step back and watch your subject engage in everyday activities.

You can raise your camera to your eye and use the viewfinder. Or with a point-and-shoot camera as well as some D-SLR cameras, you can compose in the monitor. Looking at the

monitor gives you the added advantage of being more surreptitious.

Notice how the subjects in these photos are not looking at the camera. Are these still portraits? You bet they are! Even though there is no eye contact with the camera, we learn a lot about the children playing at the beach (below), a young girl reading (top right), and a boy learning about nature (right).

Tools:

- Candid photography
- Slice of life
- Coaching a pose
- Complete set-ups

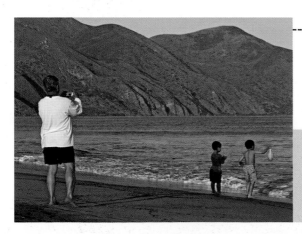

Exposure Mode: Manual
Lens Focal Length: 80mm
Aperture: f/10
Shutter Speed: 1/400
Metering: Evaluative

Candid portraiture is one of the best ways to get terrific portraits of camera-shy children, or children who "ham it up" for the camera.

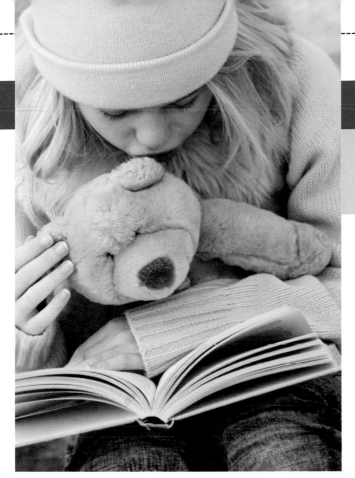

A candid moment , such as this girl reading with her Teddy bear, is a wonderful portraiture opportunity.

Your child's exploration of the world can be photographed from a distance with a telephoto lens.

Exposure Mode: Manual
Aperture: f/2.8
Lens Focal Length: 70mm
Metering: Matrix
White Balance: Manual

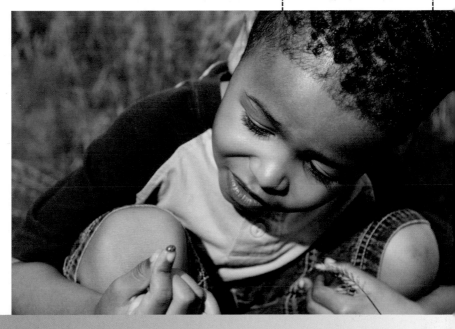

When you move in closer to your subject, your physical presence makes it harder to take true candid pictures. You're simply more of a distraction. I've mastered a sneaky method of casually aiming without my subjects even realizing I am about to shoot the picture.

First I put my camera to the widest lens setting (a low focal length number) and move in close. The key is to hold the camera low, "shooting from the hip" without looking through the viewfinder or raising the LCD monitor to eye level.

Just try to aim the camera straight at your subjects and push the shutter release button. Sure, I get oddly framed shots often and occasionally I completely miss the person in the picture, but I simply delete those. The camera usually does a great job of focusing and exposing the picture, and every once in a while I get an amazing portrait.

Slice of Life

I call a picture a "slice of life" when your subjects know they are being photographed, but the picture-taking becomes less of an ordeal because it isn't a "line up against the wall and smile" situation.

Instead, you're making photography fun by taking pictures of daily life. If you do it often enough, your family and friends will start to consider it normal. Potty training for kids, homework for adolescents, and a trip to the library or store are all great portraiture opportunities for the creative photographer. These bits of daily life may well be the portraits you'll end up cherishing the most in the years to come.

Lens Focal Length: 24mm
Aperture: f/3.5
Shutter Speed: 1/60
Equivalent ISO: 800
Metering: Evaluative
White Balance: AWB

Grab your camera, even when you're just going on a trip to the store. Slice-of-life portraits are available everywhere, every day!

Start picking up your camera in seemingly mundane situations, and you'll find wonderful slice-of-life portraits!

Lens Focal Length: 30mm
Aperture: f/5.6
Shutter Speed: 1/60
Equivalent ISO: 200
Metering: Evaluative
White Balance: Auto

Lens Focal Length: 50mm
Aperture: f/2.5
Shutter Speed: 1/160
Metering: Spot on faces

Coach a Pose

The next step is to start coaching your subjects into a pose. You can offer simple instructions that usually work quite well, such as, "Pick up your baby brother and give him a kiss!" You don't have to manage every detail of the pose, just see what happens when you offer a general direction to your subject.

Lens: 200mm
Aperture: f/5.6
Shutter Speed: 1/140

Every child has played the game of peek-a-boo, so instigating this game photographically is a great tool when shooting younger children. If shooting in a park, I like to hide behind one tree and start the game. Just be sure to have your camera ready for when it starts. It's almost impossible not to get a cute picture of a child when playing this game!

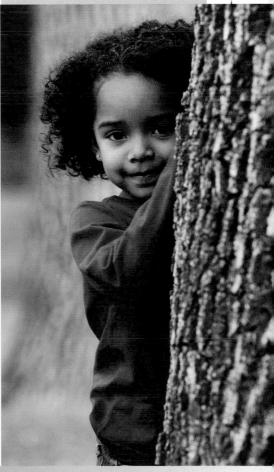

You can also try coaching in a more unobtrusive manner. My favorite semi-candid method is to simply call out to your subject so they look up from their activity and at you for a moment. And if you're ready, a moment is all you need to capture it in a picture. But be prepared—that first unguarded moment is usually the best. This is an excellent technique for shy or uncooperative models.

Tip

Adding props can give a sense of scale to a picture, or it can create a mood, tell a story, or just add a dash of color. When you want a more candid style, props help relax your subject by giving them something to do.

Exposure Mode: Manual
Lens Focal Length: 157mm
Aperture: f/4

Shutter Speed: 1/800
Metering: Matrix
White Balance: Auto

Lens Focal Length: 200mm
Aperture: f/11
Shutter Speed: 1/125
Equivalent ISO: 100
Metering: Center-weighted
White Balance: Auto (AWB)

Complete Setups

Most folks have a little "ham" in them and like to role-play, especially kids—so they're often willing subjects for completely staged "candids." By that I mean photographs that are supposed to look like a part of daily life, but are really staged and choreographed.

It can be as simple as asking your son or daughter to pretend to sleep beneath the Christmas tree, or in bed amidst all the stuffed animals. Or it can get more complex,

like whipping up a frothy bubble bath and then painting a bubble beard on your two goofball children.

Don't worry! Setting up a shot like this is not cheating—it's theater. And it is a great way to shoot holiday cards or special themes.

2.2 Getting Started
The First Steps

Tools:

- Shooting verticals
- Backgrounds
- Zoom in for design
- Fill the frame

Shooting Vertical

My first tip is straightforward. A person is vertical. As such, most pictures of a standing person or head-and-shoulders portraits should be vertical. So turn your camera sideways to take the picture! This will allow you to fill the frame with more person and less background.

There are two main exceptions to this rule:
- Your subject is not standing, so they may no longer be vertical.
- There is a compelling design reason to shoot horizontally—such as you want to show a particularly beautiful or interesting background.

Background

And speaking of background, many portrait photographers wonder exactly how much of

Exposure Mode: Auto
Aperture: f/4
Shutter Speed: 1/125
Equivalent ISO: 400
Exposure Compensation: +0.67 EV
Metering: Matrix
White Balance: Custom, 4500K

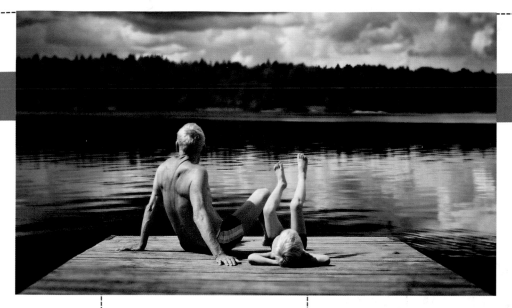

Lens: 40mm (above)
and 17mm (right)
Metering: Evaluative
White Balance: Auto (AWB)

it they should include. The answer is to look for balance. If the background is ugly or just boring, crop most of it out. A portrait is about the person; so only include background elements that tell the story of that person or that moment in the person's life, or add to the design of the picture.

For example, the picture of a man and his grandson (above) is about their enjoyment of a sunny day on the water's edge. Compare this to the view (right) that shows more sky. Now the picture is more about the lake and the two people within a natural setting. Both are memorable pictures. And I consider both to be portraits because they tell us a lot about the pair. But they are very different interpretations of the same basic scene.

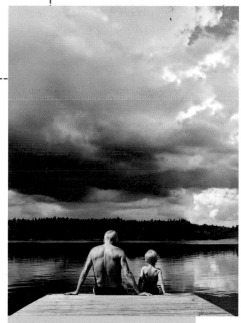

In the above version of this scene, a wider lens setting was chosen. This made the picture more about the lake and the two people. The top version is more about their relationship.

Lens Focal Length: 162mm
Aperture: f/5.0
Shutter Speed: 1/8
Equivalent ISO: 200

Fill the Frame

Unless you have a compelling reason to show the background, always try to "fill the frame." This means you should create a picture where the entire image is filled with just your subject. There are three ways to do this:

1. Zoom your camera to the telephoto setting, or if you are shooting with a D-SLR camera, switch to a longer focal length (like a 100mm or 200mm). This will magnify your subject in a way similar to using binoculars.

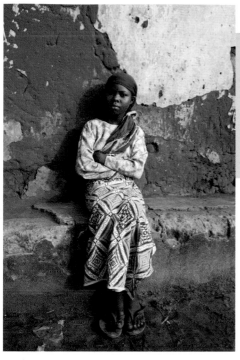

Look at the three photos of the girl sitting on a stone bench against an outdoor wall (left, top to bottom). The top image was shot with the widest-angle lens 18mm. For the middle photo, the lens was zoomed to 37mm. And for the last, the focal length was 55mm.

2. Step closer to your subject. This will make them bigger in the viewfinder and on the monitor.

3. Try doing both to deliver the best results.

Start by eliminating all the unwanted background. Don't forget to turn your camera into a vertical position if the photo calls for this format. After you do this, look at the picture on the monitor. Then ask yourself, "Do I need the whole person's body in the portrait, or all that background?" The answer is probably, "No." If so, get even closer with your lens, your camera position, or both.

In the example shown at left, all three portraits of the young lady in the blue scarf work. However, the second and third are probably the most compelling, because "extra" background was eliminated by zooming the lens.

2.3 Eye-Level Choices
Your Vantage Point is Very Important

Tools:

- The eye-level rule
- Breaking the rules
- Looking down
- Looking up

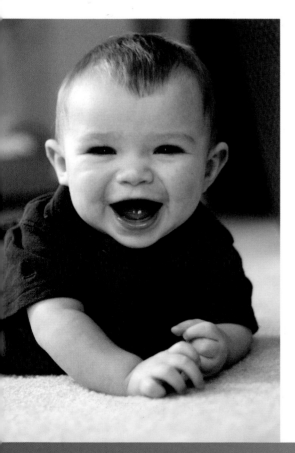

The Eye-Level Rule

Most pictures will look best if you shoot from your subject's eye level. With adults of similar height as you, this usually means you are both standing and you raise the camera to the height of your eyes. But when photographing taller or shorter individuals, you will have to move by either stepping up onto your toes (or a box or curb), or squat down a bit lower. Seated adults and children may require you to shoot on your knees. And if they are lying down on the ground—well, you should be too!

As mentioned earlier, you can avoid some of these gymnastics by holding the camera lower and shooting without looking through the viewfinder. Some cameras with tiltable LCDs allow you to view the monitor while holding the camera at odd angles.

Exposure Mode: Auto
Lens Focal Length: 170mm
Aperture: f/3,5
Shutter Speed: 1/500
Exposure Compensation: -0.33
Metering: Spot (on faces)
Subject Distance 5m (16.4 feet)

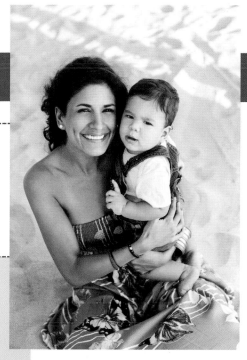

Exposure Mode: Auto
Lens Focal Length: 70mm
Aperture: f/3.2
Shutter Speed: 1/500
Equivalent ISO: 200
Metering: Spot (on faces)
Subject Distance 1.5m (4.9 feet)

You can make a huge improvement in your portraits simply by zooming to a telephoto lens or lens setting and getting down to your subject's eye level.

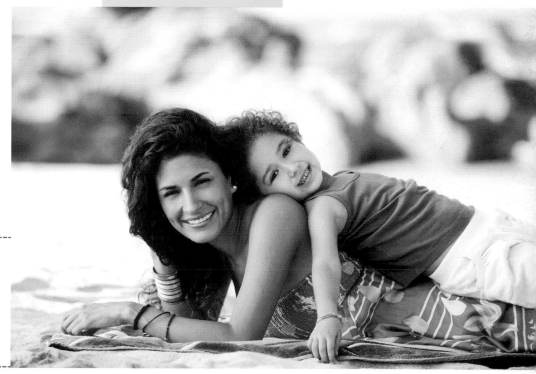

Breaking the Eye-Level Rule

I completely understand that I have empha-
sized how most portraits will look best if
shot at the subject's eye level. It's simply the
fastest way to improve most portrait pictures.
That being said, there are certainly times you
may want to break this rule.

When to Point the Camera Down

There are several situations where you'll
probably want to pick a high angle of view
and break the eye-level rule. The first is when
you want to highlight the relatively diminu-
tive size of your child. Looking down from an
adult perspective shows this.

Exposure Mode: Auto
Lens Focal Length: 50mm
Aperture: f/3.5
Exposure Compensation: +0.33
Equivalent ISO: 100
Flash: Fill Flash
Metering: Evaluative
White Balance: Auto
Style: Landscape

Looking down at your child with a
wide angle lens from a high angle
causes optical distortion so that the
head looks disproportionately larger
than the rest of the body. This distor-
tion can give a diminutive feeling to
the picture, making a youngster look
even smaller and cuter.

Looking down also enables you to better see
what a child may be playing with or holding.
For example, in the image at left we see the
water and exploration of a young boy and his
father on the beach.

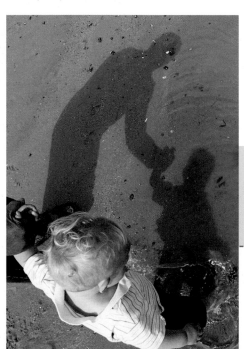

A high vantage point
let's you share the
boy's experience as
he plays in the water
and watches his
shadow.

Lens Focal Length: 12mm
Aperture: f/9.5
Shutter Speed: 1/125
Exposure Compensation: -0.5
Equivalent ISO: 100
White Balance: Daylight

Going to an even higher perspective—a true bird's-eye view—where you are looking straight down gives portraits a disconnected, omniscient feel; like you are secretly viewing someone else's piece of the world . This is the case in the photo of the boy and his father on the beach on page 36.

Traditional portrait photographers from days gone by often photographed women from a position slightly higher than eye level. This was because the vogue of the time was to make the "fairer sex" look more diminutive and child-like. Men on the other hand were often photographed from a slightly lower angle to make them look bigger and more powerful.

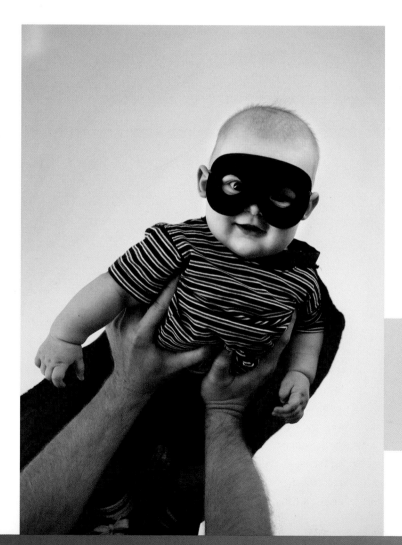

Looking up at your subject is the traditional Hollywood "power" pose, so it enhances the flying superhero pose of the toddler at left, and the woman at right.

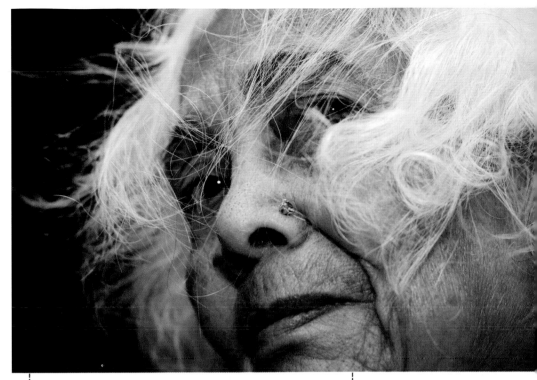

Exposure Mode: Manual *Metering:* Evaluative
Lens Focal Length: 50mm *White Balance:* Cloudy 6500K
Aperture: f/4 *Exposure Compensation:* +0.2
Flash: Red-Eye Reduction Mode *Brightness:* +3
Shutter Speed: 1/125 *Contrast:* +43

When to Point the Camera Up

There are times when you may choose to break the eye-level rule by pointing your camera up. The most common reason to do this is to make the subject look taller and emphasize height. Or, if the sky is particularly beautiful, or the trees are in flower, you might choose a low angle to show the background. Sometimes a busy and distracting background can be avoided by using all sky. Because looking up is an unusual angle, it can add interest to a portrait, such as the image of a mature Indian woman (above).

A bug's-eye view of the world can be fun too. Try lying on your back and have your subjects peer at you, like you are a science project. It may be helpful to turn on your camera's fill-flash, because their faces will probably be in shadow against a bright background of the sky. (See Chapter 5 for more information on using flash.)

Composing Your Portraits

Any picture is made up of visual elements. In a portrait, some are more important than others. Usually the most important elements are the eyes. Secondary elements include other important body parts (like hands, especially if they are holding something), the horizon line, and significant foreground and background items.

By separating the important visual elements in a photo, the picture viewer's eyes dance from one point of interest to another around the picture. If you measured the amount of time a viewer spends looking at a successful picture's multiple points of interest, you will find it is much longer than average. This ability of a photograph to hold a viewer's attention is called visual excitement, and the best pictures have it. Let's look at some of the ways you can create and incorporate this type of visual excitement into your portraits.

3.1 Avoiding Bull's-Eyes
Off-Centered Composition

Where you decide to place the important visual elements in a photo can make a huge difference in how successful an image is. For example, a picture where the subject's eyes are exactly centered in the frame is rarely a strong photo.

The Rule of Thirds is a guideline that will help you create balanced, off-center compositions. Begin by imagining your viewfinder or monitor divided as a tic-tac-toe board, with nine equal sections. This grid divides the frame into three columns and three rows.

Tools:

- Rule of thirds
- Looking in, looking out

If you place important picture elements on these lines and on their intersection points (or even further out from the center), you'll end up with a more balanced design. Since the sections are equal in size, it works just as well on vertical compositions as horizontal.

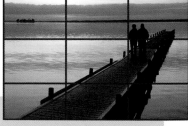

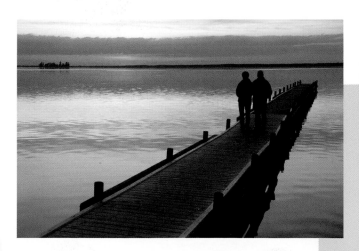

If you divide your photo into nine equal segments, the important picture elements should be near the intersection points or along lines to avoid centered compositions. You can even push it further, such as having the horizon even further up than the high line.

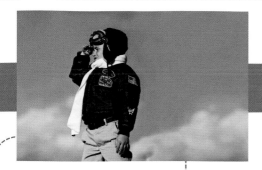

Lens Focal
Length: 85mm
Aperture: f/2
Shutter Speed: 1/8000
Equivalent ISO: 200
Exposure Comp: -0.33

It is important to give your subjects "room" to look, walk or run into. Notice how the photo at right feels more balanced than the photo above.

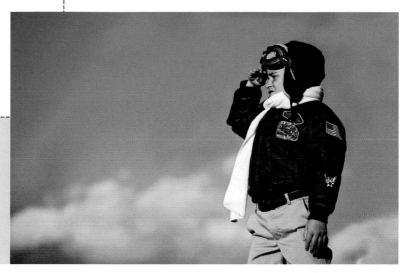

In or Out?

Another compositional rule deals with portraits in which the person is not looking at the camera. You need to leave room in the frame for your subject to look or move into. For example, in the portrait of the young aviator (above), the boy's body and eyes are pointing to the left, so the most successful composition puts him to the right of the photo, where you can follow his gaze as he looks all the way across the picture.

did u know?
The Rule of Thirds was a common compositional aid with the painters of olden days. Any trip to a museum will show countless examples!

Don't forget to use Focus Lock. Any time you move the subject significantly off center, you risk the chance of the camera focusing on a more distant background instead of the subject. The result is an out-of-focus portrait.

3.2 Using Lines
for Design

The Horizon Line

The horizon line can be an important picture element when it is seen in a photograph. In landscape and scenic photography, it is immensely important and is often placed high or low in the picture to follow the Rule of Thirds (see page 42).

In portrait photography, however, it can be a distraction. Why such a difference? Because in portraiture the horizon line is of secondary importance, and it is a very graphical picture element that can pull your attention away from the your subject if put in the wrong place or put slightly askew.

Compare these three beach portraits of the woman with the pink flower in her hair (next page). In the top image, the camera was accidentally held at an angle, resulting in a distracting tilted horizon line. In the middle image, the horizon intersects with her face at exactly eye level, which creates a distracting result. In the lower, the horizon is below her eyes and therefore less distracting.

Lens Focal Length: 42mm All variations were created in Adobe Photoshop.

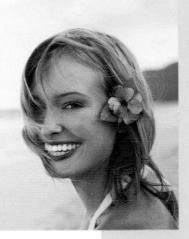

The horizon line is incredibly important in your picture. If it is slightly crooked (top left) the picture may feel unbalanced.

If it intersects with an important element in the picture (such as the eyes, center left), it can be distracting.

A lower horizon line (that does not intersect the eyes) improves the overall result (below).

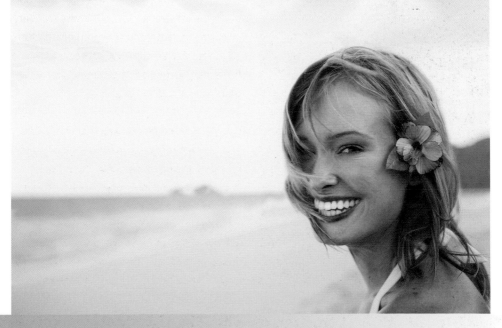

Purposeful Tilts

A picture from a camera that is slightly tilted can be disconcerting. We are used to seeing the world straight, and the tilted horizon line can feel wrong. It is easy to correct in image-processing software, but you will lose some of the outer edge of the frame when you adjust the image rotation and then crop to straighten.

This doesn't mean your camera needs to be level every time you shoot. Taking purposely tilted images can be a very effective portraiture technique because it adds diagonal lines and a bit of excitement. But in general, if you do it on purpose, do it boldly! Tilt the camera significantly, such as in the picture below.

Diagonal and Curving Lines

Diagonal and curving lines are considered much more dynamic than a strictly horizontal or vertical line, and add liveliness to a picture. The best type of lines help to accentuate important picture elements by drawing

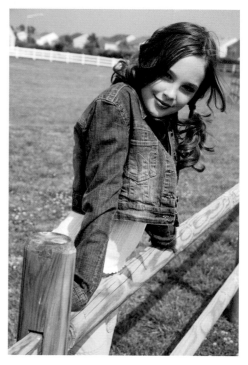

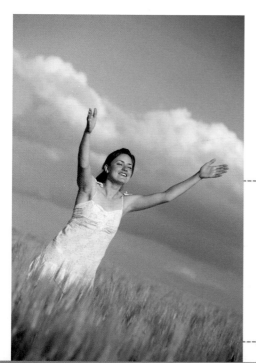

Exposure Mode: Auto
Lens Focal Length: 100mm
Aperture: f/4
Shutter Speed: 1/3200
Equivalent ISO: 200
Metering: Matrix
White Balance: Manual 5150K
Brightness: +50
Contrast: -25

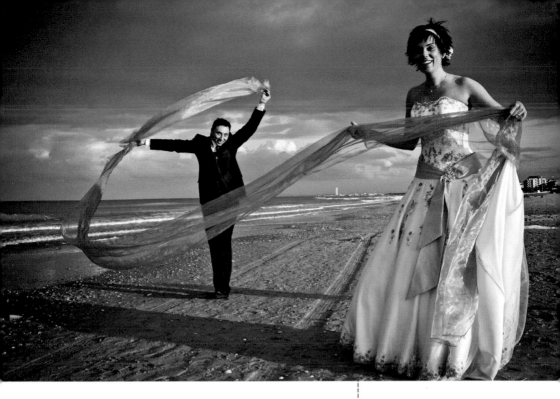

our eye back to them. The lines can be bold and obvious, like the curving pink scarf held by the bride and groom (above), or the line of a fence (left). Circular or triangular compositions are generally the richest, because they create an endless loop that has our eyes dancing all over the picture.

Exposure Mode: Manual
Lens Focal Length: 35mm
Aperture: f/9
Shutter Speed: 1/100
Equivalent ISO: 200
Metering: Evaluative
White Balance: Manual, 4200K

The clouds, the horizon, and the man's arms create strong horizontal lines, while the man's body and the greenery compliment them with diagonal lines.

3

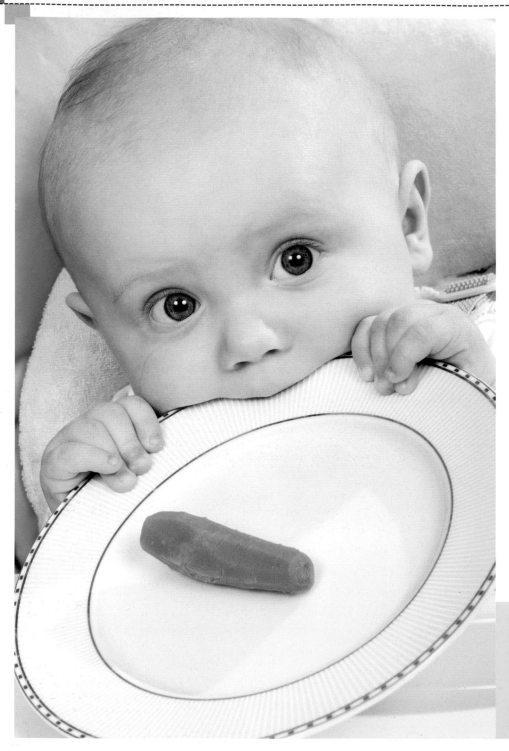

These visual elements can also be much less obvious, as in the photograph of a girl and her pumpkin (bottom right). The subtle visual lines hold together the important picture elements, as demonstrated in the yellow oval shown on the top right. Most viewers' eyes do the following:

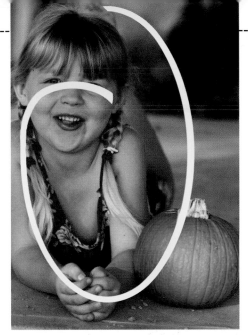

- Start at the girl's eyes,
- Travel down the pigtails to her hands,
- Go through the pumpkin and up its stem,
- Cross over to her toes,
- And drop back down to her eyes to start all over again.

The more time you can keep the viewer's eye traveling unconsciously around your picture, the more successful it is.

The yellow line demonstrates how a viewer's eye may travel around the composition because of subtle curving compositional lines. In general, the longer the eye moves around the picture, the more successful it is.

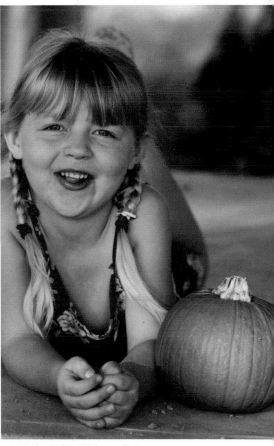

The photographer used a wonderful mixture of a tilted camera, strong diagonals (the carrot and the line of the eyes), and curves (the plate) for an endearing baby portrait.

3.3 Backgrounds
Make a Big Difference

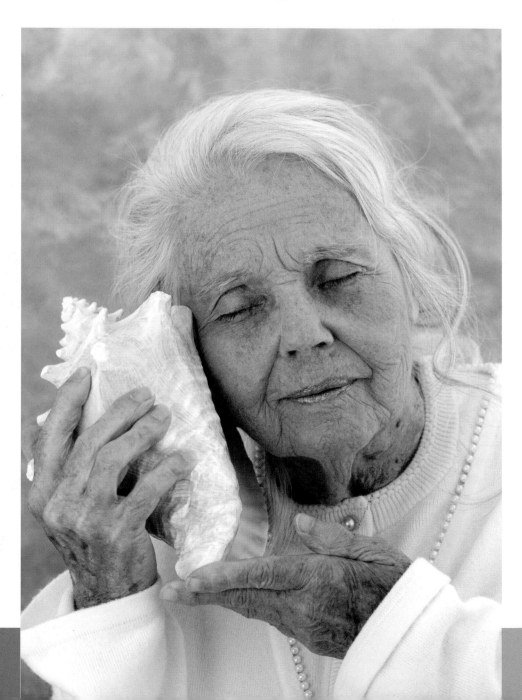

Control Your Backgrounds

You can significantly alter your horizon line—or just about any background—by changing your shooting position. Walking a circle around your subject will give you a lot of choices. So will going higher or lower.

A good exercise is to take your picture and review it in the LCD monitor. Ask yourself, "Is there anything in the background that I don't like?" If so, most likely it is a distracting element like bright colors, highlights, words, or graphic lines (or a combination of these). Try to find a camera position or lens setting that will reduce or eliminate the distractions. The difference between good photography and great photography is taking the time to do this kind of analysis and then shooting again.

Not Just Backgrounds

Don't forget to check your foregrounds, and even your subjects, for distracting elements. In the photo on the opposite page, highlights are visible on the woman's hands. These bright spots naturally draw our attention—and that's bad, because we want the viewer to look at her eyes. Don't believe me? Cover the highlights for a moment with your fingers and see if it improves the picture.

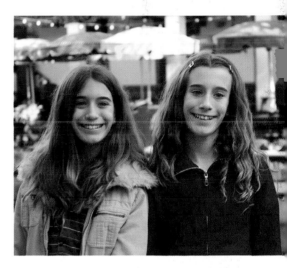

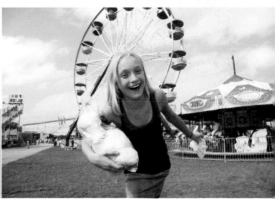

Make sure you are aware of what is in the background when taking pictures of people (top right). Bright colors or a Ferris wheel growing like a halo around your subject's head can be very distracting (right).

Simply adjusting the shooting angle changed the background from grass (above, looking down at the subject) to sky (below, looking up at the subject). Both look great, but they demonstrate how radically you can transform the background merely by altering your shooting angle.

What Makes a Good Background?

For portraiture, a good background should be one or several of these following things:

• **SIMPLE:** It does not rob attention from the person in the photo.

• **HARMONIOUS:** The colors or shapes complement the person.

The background here is rich because you have a surprise—a little brother ready and willing to give his sister another big push.

• **GRAPHICALLY INTERESTING:** It introduces an exciting graphic element to the picture, such as bold shapes that do not distract.

• **STORY TELLING:** It tells us something about the person's life.

• **PLACE SETTING:** It tells us something about where the person is at the moment.

3.4 Framing

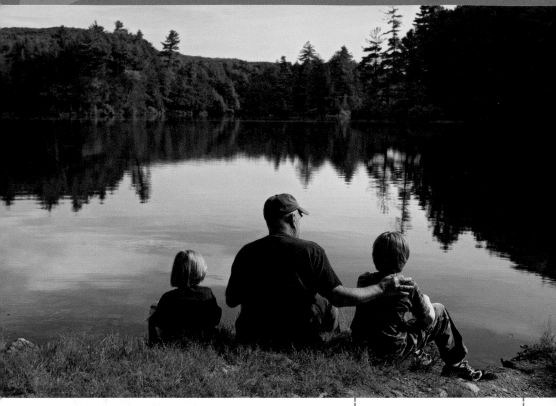

Lens Focal Length: 45mm
Aperture: f/2.8
Metering: Evaluative

Framing

Framing your subject is another fun technique that brings special emphasis to the person. It can be quite literal, such as placing them in a window frame, or more subtle such as the reflection of trees in the lake that becomes a dark frame around the family trio.

Framing can also be more subtle, like the way the reflections of trees create an arch around a grandfather teaching the grandkids how to fish, or the distant railroad suspension arch that frames a man's face and emphasizes it as he turns back to say goodbye.

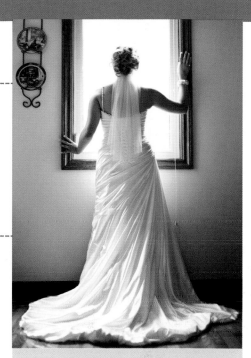

Exposure Mode: Manual
Lens Focal Length: 50mm
Aperture: f/2.5
Shutter Speed: 1/250
Equivalent ISO: 2000
Metering: Matrix
White Balance: Manual
Subject Distance: 3.6 m (11.8 feet)

You can use windows or other compositional elements to "frame" your subject as a way of emphasizing the person in the photo. Notice how the reflection of the trees (previous page), the blanket (left) and the window (above) all serve this purpose.

3.5 Shadows

Produce Extraordinary Compositions

In the Lighting chapter, we will spend a lot of time discussing how to minimize dark shadows on your subject for more flattering portraits. However, there are times when you can use shadows to improve the graphic design of your pictures. Interesting shadow patterns on your subjects face (right) can add intrigue. While the shadow itself (below) can tell the whole story.

Lens Focal Length: 55mm
Aperture: f/4
Shutter Speed: 1/250
Equivalent ISO: 160
Metering: Evaluative
White Balance: Manual

Hard-edged shadows from direct, undiffused light create the boldest lines. Direct sun or a bare light bulb are good choices.

Lens Focal Length: 38mm
Aperture: f/6.3
Shutter Speed: 1/125
Metering: Evaluative

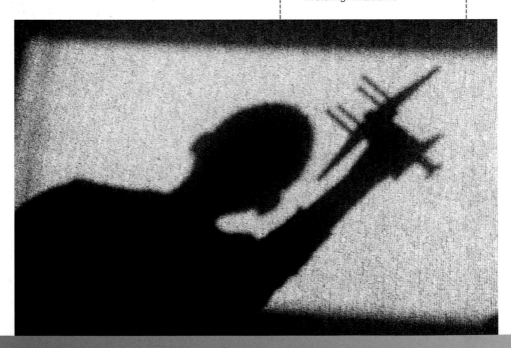

POSING & PLANNING

Let's take a look at how to make candid photos and gradually move into ways to set up more posed pictures. This is important because many of our potential models, and many of us photographers, cringe at the idea of posed portraiture. For the models, it is probably because they have had unflattering portraits taken in the past.

For the photographer, it is usually a reluctance to intrude on the person's privacy, the fear or embarrassment of having to show them a less than perfect portrait, or a combination of both. If you practice the tips in this chapter, these fears and reluctances will become a thing of the past.

4.1 Body Position
Small Changes, Big Differences

Shoulders & Hips

Nobody ever likes his or her driver's license picture, and that is partly because the pose (squared off and staring at the camera) is rarely the most complimentary. It is often best to turn the torso and hips at an angle to the camera, even if the subject is looking at you. Start by positioning the model's shoulders at an angle of about 45 degrees to the camera. Usually I coach this by asking them to slowly start stepping in a partial circle. Once they are at the angle I want, I say, "Now look back at me without moving your shoulders."

Tools:

- Angled shoulders and hips
- Posing the hands

Straight-on shots are rarely as flattering as those where the shoulders and hips are slightly turned at an angle to the camera. Talk to your subjects to coach them into a different position if you find they are facing you directly.

Hands

Hands are tough to pose naturally. Most subjects become very self-conscious of their hands when you start to take their portrait. They just don't seem to know what to do with them! It is often a good idea to coach them into an attractive hand position. I think of the hands as a graphic element, and ask yourself if they add to the picture or distract from it.

Especially with women, a side view of the hand generally makes it look more elegant and the fingers more elongated, whereas showing the palms or back of the hands is less graceful. Even the most delicate hands can look big and bulky when their broadest side is photographed.

Delicacy is not as important in most male portraits, but they still need to be posed in a flattering manner. In general, showing the hand in profile (from the side) is usually the most desirable.

It might feel unnatural for a person to hold their hand that way, but you can make it look both natural and graceful if you coach the exact position, like having the model frame their chin with their fingers.

Tip

If you want to alter a person's posture, you can ask them to put their hand on their hip or tuck the fingers of one hand into their pocket. This will often cause them to shift their hips and look more comfortable.

The broad back of the hand (upper photo) is less dainty than the side view of the fingers (above).

4.2 All About Eyes

Eye Direction Matters

Tools:

- Eye contact
- Eye direction

Eye Contact

We have already stressed the importance of your subjects' eyes in portrait photography, and the advantages of shooting at eye level. But what about the direction of the eyes, especially when there are two people (or more) in the portrait? Eye contact can change the feeling of the picture in several ways.

EYES AT CAMERA: If the subjects are looking at the camera, the viewer feels related to the people. This is the classic portraiture technique. Ask your subjects to look at the lens.

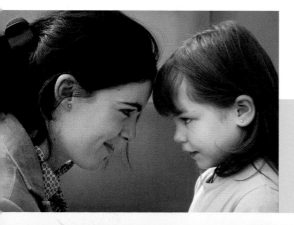

Having a mom and daughter look at each other increases the feeling of their bond. Add the touching foreheads, and this bond is depicted physically as well.

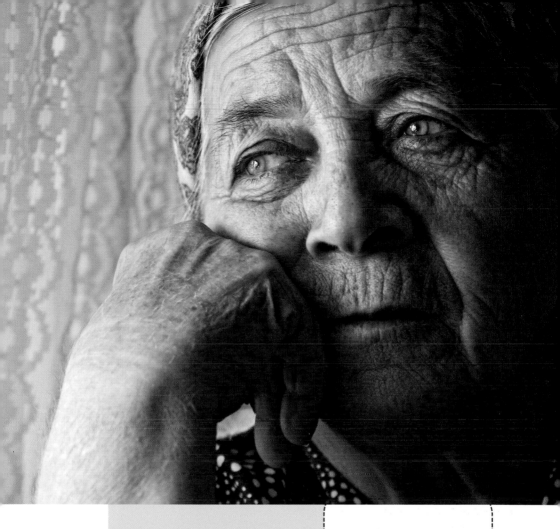

When your model is captured looking off into the distance, such as this mature woman watching through her window, you can create a pensive mood.

Exposure Mode: Manual
Lens Focal Length: 50mm
Aperture: f/2.8
Shutter Speed: 1/40
ISO 400
Metering: Evaluative
White Balance: Auto (AWB)

EYES AT EACH OTHER: This is a great way to communicate the connection between two individuals. The subtext or story of this portrait is the bond they share.

Both photos above are nice family portraits, but the story each tells is different. When the father and children turn toward the mother (left), the picture becomes about her. Perhaps it is her birthday or Mother's Day.

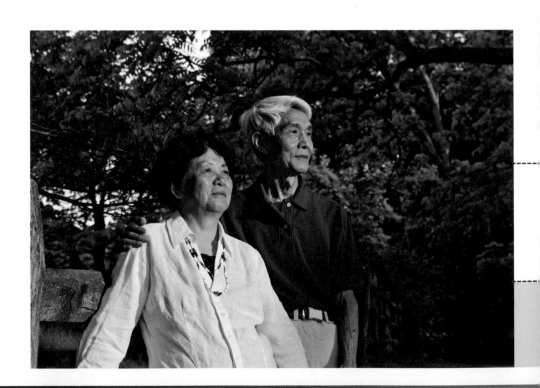

This family portrait is all about the baby girl, because everyone's eyes are on her.

Exposure Mode: Manual
Lens Focal Length: 160mm
Aperture: f/3.5
Shutter Speed: 1/200 second

Exposure Compensation: +0.33
ISO: 200
Metering: Center-weighted
White Balance: Auto (AWB)

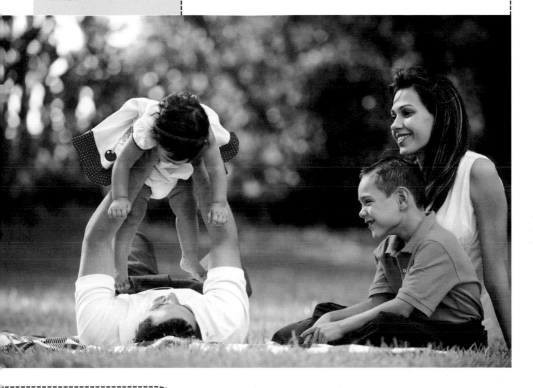

Exposure Mode: Auto
Lens Focal Length: 70mm
Aperture: f/9
Shutter Speed: 1/50 second
ISO: 200
Metering: Matrix

Looking off into the distance in the same direction evokes a unity through shared experience.

EYES AT ONE PERSON: When one or more people are looking at a single individual, the story is about the person being observed, and the love and respect the others have for him or her.

LOOKING AWAY IN THE SAME DIRECTION: This creates a moodier portrait that is still unified because your subjects are gazing at something with shared interest.

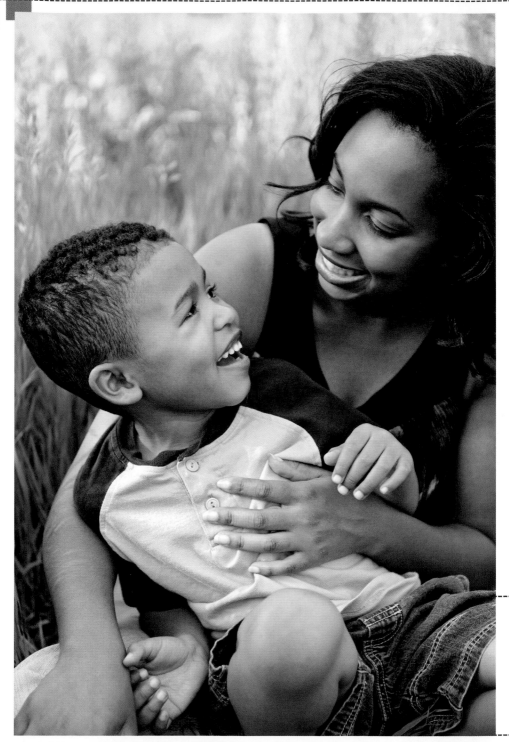

LOOKING AWAY IN DIFFERENT DIRECTIONS: Discord is created by this composition, and it is rarely perceived as a loving pose. Turning bodies away from each other will enhance the discord. If one person is looking at the camera, this will be the most "important" person in the picture.

LOOKING DOWN: Downcast eyes can create a moody, contemplative pose. It can even go so far as to illustrate a concept like "depression" or "sadness." The exception is when the subject is looking down at something specific, such as a brother and sister reading a book together.

This portrait looks disjointed because the man is looking away from the woman and the camera. His body is also turned away from her.

Lens Focal Length: 130mm
Aperture: f/5.0
Shutter Speed: 1/200 second
ISO: 100

Exposure Mode: Auto
Lens Focal Length: 92mm
Aperture: f/11
Shutter Speed: 1/500 second
ISO: 400
Metering: Evaluative

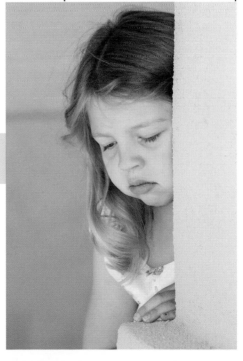

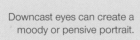

Downcast eyes can create a moody or pensive portrait.

Exposure Mode: Auto
Lens Focal Length: 70mm
Aperture: f/3.3
Shutter Speed: 1/180 second
ISO: 200
Metering: Matrix
White Balance: Manual

4.3 Size Differences

Lens Focal Length: 100mm
Aperture: f/4.5
Shutter Speed: 1/160- second
ISO: 200

Uneven Heights

People of uneven heights can cause a posing problem. If you want to equalize differing heights for a more face-filling shot, consider seating them. When including children with adults, a lap works great—as does a piggyback ride.

When this grandmother and grandson are standing next to each other (bottom left), their height difference is much greater than when they are sitting (below).

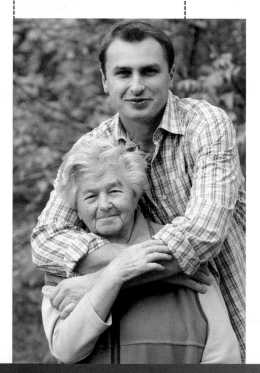

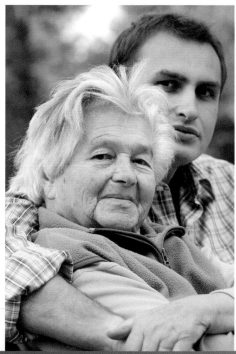

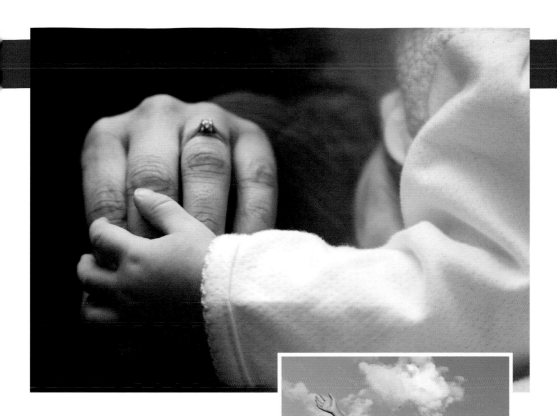

The size difference between young children and their parents can be bridged by a whole host of fun and creative poses.

Compare the Size Difference

Alternately, you can emphasize the height differences, such as the portrait of three siblings of different ages (right).

Comparing the size differences of a baby's hand to her mother's hand (top) can sometimes tell more about the size difference (and the mother-child bond!) than a full body portrait.

Lens Focal Length: 44mm
Aperture: f/8
Shutter Speed: 1/400- second
ISO: 100
Metering: Evaluative

4.4 Photographing Pairs

A Unified Pair

Groups of two are a challenge to the photographer. Often people tend to stand next to each other, shoulder to shoulder, frequently not touching. Alternately, after years of being told to "get closer" for pictures, they may lean in toward each other and crane their necks to get their heads closer together. Neither is particularly attractive.

For successful portraits of more than one person, it is important that the subjects are visually unified as a pair or group—but this needs to appear natural.

Friends and family members can be encouraged to put their arms around each other for a portrait that communicates their bond *and* closes the gap between them.

Another method is to try to overlap their bodies a bit to avoid having them lean toward each other, which can look awkward. Instead, have one person positioned with their body slightly in front of the other so they visually overlap at the shoulders. Be sure the shorter person is the one in front!

Other types of physical contact are a great way of creating a harmonious portrait of two people. Coach your subjects to rub foreheads or noses, or give a big noisy kiss on the check. All may elicit wonderful expressions!

Notice how disconnected the man and woman look in the photo at left. This disunity is caused by three factors:

1. They are separated by space (there is a big gap between their heads).
2. They are not looking at each other.
3. Their bodies are turned away from each other.

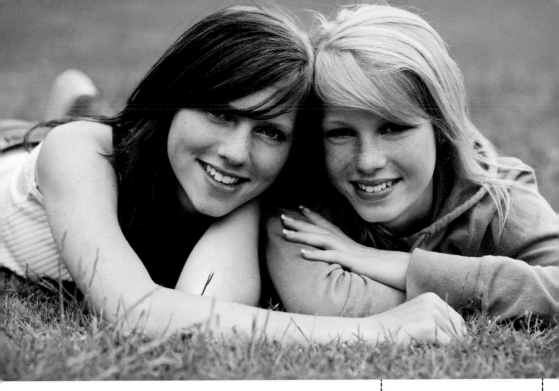

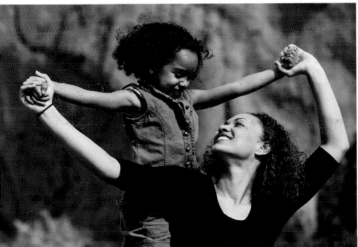

Exposure Mode: Auto
Lens Focal Length: 80mm
Aperture: f/4
Shutter Speed: 1/125
Exposure Comp: +0.67
ISO: 160
White Balance: Auto (AWB)

Exposure Mode: Aperture Priority
Aperture: f/16
Shutter Speed: 1/250 second
ISO: 200
Metering: Spot reading on brightest area
White Balance: Auto

Notice how the eye-contact communicates their bond, and outstretched arms creates dynamic lines that improve the composition.

4.5 Posing Groups

The More People, the Harder it Gets!

Tools:

- Turned to center
- Layering (stacking)
- Orchestrating the pose
- Shoot lots of extras
- Pulling it all together

When you start adding more than two people to the portrait, body position becomes even more critical. Putting everyone in a lineup, shoulder-to-shoulder, is bad because this creates a picture with a number of gaps. It also makes everyone's heads relatively small, with too much empty space above and below the people.

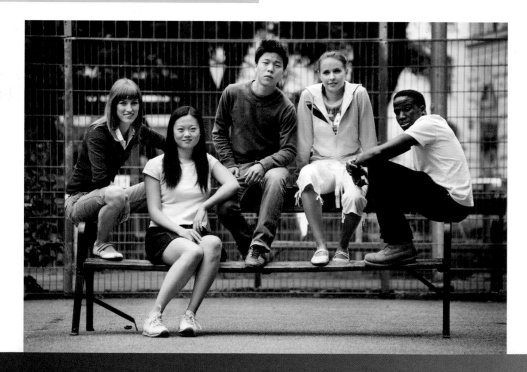

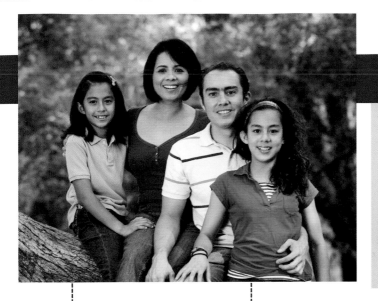

did u know?

Since the 1800s, generations of photographers have used the "Layering" or "stacking" techniques for posing large groups.

Exposure Mode: Manual
Lens Focal Length: 90mm
Aperture: f/3.5
Shutter Speed: 1/160 second
ISO: 100
Metering: Center-weighted
White Balance: Auto (AWB)

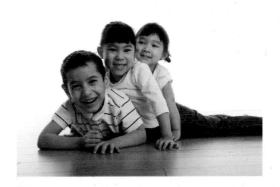

Turning to the Center

A quick way to improve group portraits is to ask the outermost people to turn slightly toward the center. This will emphasize the cohesiveness of the group. If they are sitting in chairs, have them swing their legs in toward the middle of the picture. If they are on the ground, have their knees, torso, or shoulders angled in a bit. The two teens in the photo at left are turned toward the center, and this helps them anchor the pose.

Stacking or Layering

Position the people so they are stacked or layered in a tight group. If, for example, you position a group on stairs or a picnic bench at three different vertical levels, the people in the picture will be relatively bigger than if they were lined horizontally across the picture because there will be less wasted space. It's quite amazing how much larger you can get each face when you take the time to position everyone carefully.

Orchestrating the Pose

My strategy is to orchestrate the pose. First I try to scout a location that gives me either an interesting or a non-distracting but pleasant background. Make note of the light too! In general, soft lighting like shade or overcast skies are best for large groups.

In a traditional group portrait, I start placing the people one by one. I begin with the anchors—individuals old enough to sit quietly for the longest time. Then I start adding people around them. The last row (usually the front) is the kids and pets. And if I plan on being in the picture, I save a space on one of the edges that I can run into.

Shoot a Lot of Extras!

When photographing groups, I take a lot of shots. The more people, the greater the likelihood that someone is going to have a bad expression. It is best to warn everyone that

A running pose is a great way to make sure young models are having fun and not getting stressed out by the photo session. Photos of them running away can be just as successful as running towards the camera, so be sure to do both!

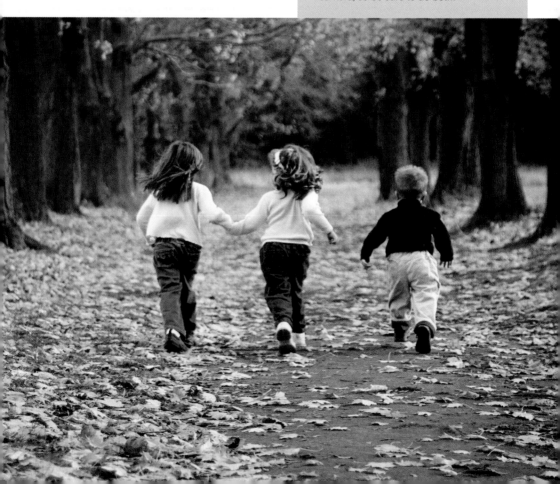

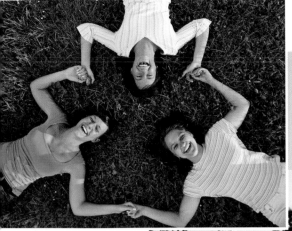

Shake it up! Traditional portraiture poses are great, and an important part of any photo album. But don't get hung up on static poses—have a little fun! Here are a number of different approaches to consider.

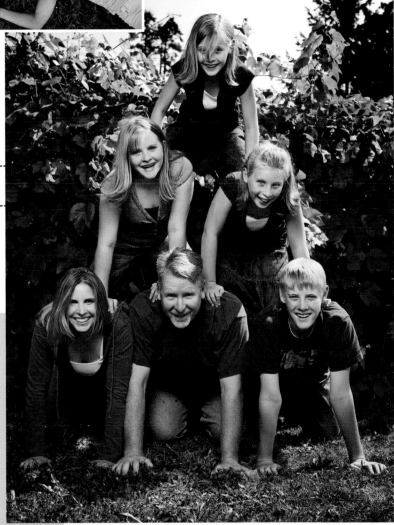

Lens: 17mm
Aperture: f/7.1
Shutter Speed: 1/250
ISO: 100
Metering: Evaluative

Lens: 43mm
Aperture: f/7.1
Shutter Speed: 1/125
ISO: 50
Metering: Evaluative

You can literally stack your subjects to make a human pyramid.

Be careful and make sure any athletic poses are age appropriate. For pyramids, you will need older subjects and "spotters" nearby just out of the camera's view, in case the pose starts to topple.

you plan to take 5, 10, or even 20 pictures of the group, so they don't break up the pose after one or two shots.

Pulling It All Together

Don't forget to apply the techniques that you've learned in other chapters to group photography as well. Try moving far away with the telephoto lens setting. Or pick an unusually high or low angle for a fresh take on the family portrait.

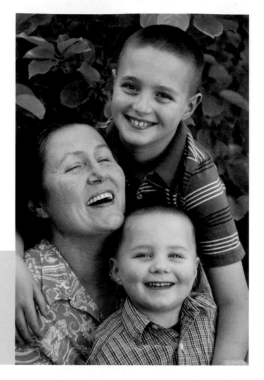

Notice how the faces are all at different levels, but are still integrated by their closeness. This creates a curving compositional line (see pages 44-49 for more on lines).

Lens Focal Length:
70mm
Aperture: f/5.6
Shutter Speed: 1/125
Metering: Matrix
White Balance: Cloudy

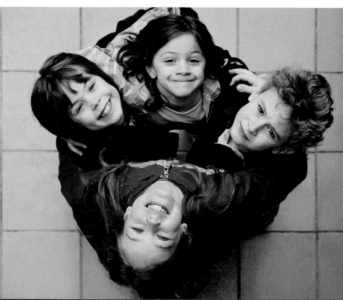

Earlier in the book we showed how eye-level portraits are usually the best. This is a great example of when to break the rule. A balcony viewpoint and a circular pose makes a fun and engaging portrait of four children with different heights.

Special Tips for Photographing Babies

GET TO THEIR LEVEL: Match their true eye level with your camera height for the most intimate portraits. Since babies are smaller than adults, you will want to raise

them if you don't want to lie on the floor to get to eye-level. The over-the-shoulder shot is a tried-and-true favorite.

BREAK THE EYE-LEVEL RULE: Sometimes a high angle on a baby is successful for portraiture. Looking down emphasizes their small size and vulnerability. Cribs are ideal for this.

EXTRA SOFT LIGHTING: Babies often look best in the softest possible light, such as light from a north-facing window. It always gives the feeling of a nursery, and the bright mood of morning.

BACKGROUNDS FOR BABIES: Pale colors go along with soft lighting for a true nursery feeling. Try to get a simple background like a blanket or sheet (left). Avoid really busy backgrounds that compete with the baby for the viewer's attention.

SIZE COMPARISONS: How small is your baby? Include a parent's hand in the picture for comparison (see page 69). You may want to make this an annual event and try to replicate the picture as your child (and his or her hands) grows.

FASCINATION WITH THE WORLD: As your baby starts to grow up, don't forget those slice-of-life pictures we've talked about. Photographs of your child exploring and learning will become treasured portraits.

USE EXPOSURE COMPENSATION: Your pictures may lose detail or look bluish when shooting a baby on white. This is because the camera is underexposing the image. Use plus (+) exposure compensation if your camera has this capability. Blue casts can also be caused by improper white balance (see page 134).

4.6 Pets & Their People

Tools:

- Uneven heights
- Kids and pets
- Emphasizing the differences

You may be surprised to learn that most of the tips and techniques in this book are applicable to portraits of your pets and portraits of people with pets. The big difference is the size of your pets compared to humans.

Just how eye-level portraits of people are usually best, when you add pets, the same is true. Have your subject raise their small pet up, or position them both on the ground (with you on the ground as well!).

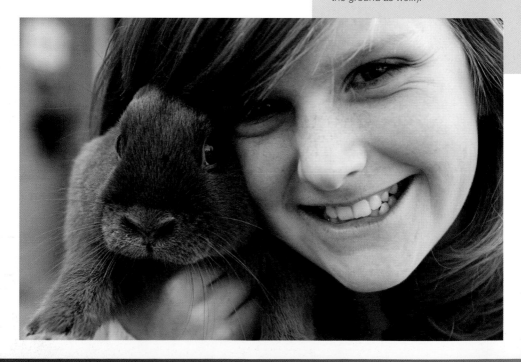

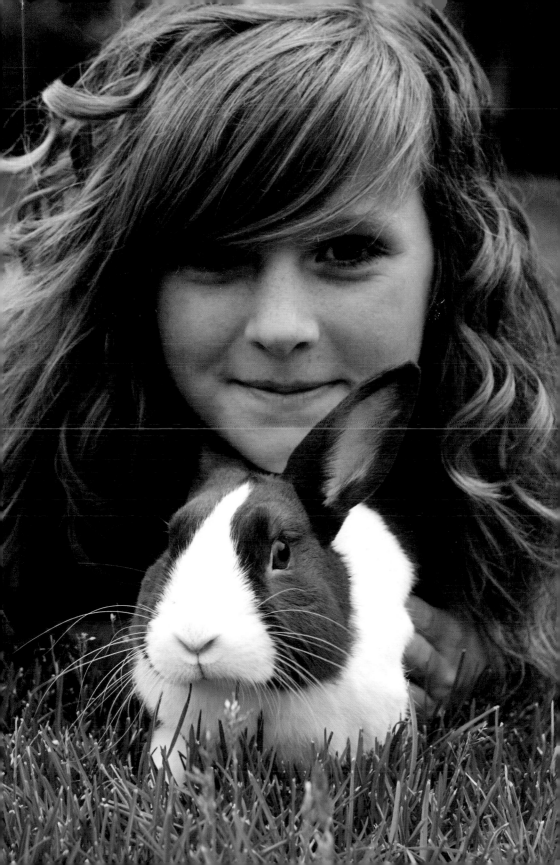

Lens Focal Length: 200mm
Aperture: f/4
Shutter Speed: 1/200
ISO: 200
Metering Mode: Matrix

It is tempting to take all your pet pictures from standing level. But it is usually best to get closer to eye level.

Exposure Mode: Auto
Lens Focal Length: 200mm
Aperture: f/4
Shutter Speed: 1/200
ISO: 200
Metering Mode: Matrix
White Balance: Cloudy

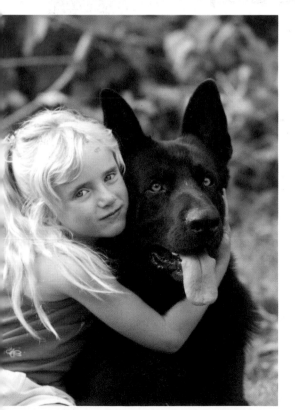

GET DOWN TO THEIR LEVEL: Even big dogs are smaller than the standing height of most people. Have your model get down to the animal's eye level in order to make pictures without the gap created by such a height discrepancy.

RAISE THEM UP: Encourage your subject to hold smaller pets. Be careful! Never allow anyone to bring a potentially dangerous pet up close to their face. Even a cute small dog can hurt someone!

CLOSE THE GAPS: Use positive training to help your human and animal subjects inter-act. Use the animal's sense of smell and love

of treats to achieve your goals. An apple in the pocket brings a horse nearby. And peanut butter on a boy's check is a sure-fire way to elicit a doggy kiss.

SHORT SESSIONS: Most pets have very short attention spans. Several short photo sessions will yield better results than one long one. Always end the photo session if the animal gets stressed.

GROUPS OF PETS: All I can say is, "Patience, patience, patience!" The more pets you put in one picture, the harder it is to get a picture where everyone looks great. Keep trying, and refer to the Short Sessions tip above.

ANIMAL BEHAVIOR: The most successful pet photographers are experts in animal behavior. Instead of trying to force an animal into a certain pose, they use their understanding of behavior to coax it. For example, a heating pad under a photogenic cloth will attract reptiles, as well as other animals in colder weather. And if you substitute tuna fish broth for peanut butter from the earlier tip on how to get a doggy kiss, you may get an adorable shot of a sniffing kittens.

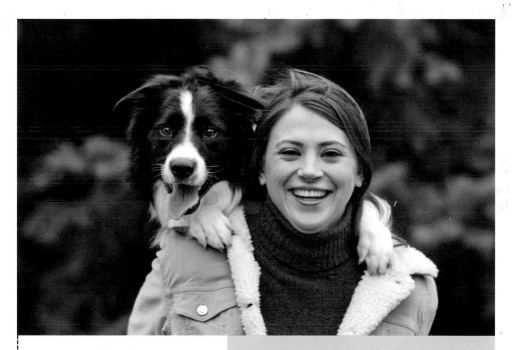

Exposure Mode: Aperture Priority
Aperture: f/4
Shutter Speed: 1/350
ISO: 250
Metering: Center-weighted Averaging
White Balance: Auto

Ask your human subject to look at the lens, and then attract the pet's attention with a whistle, chirp or fake bark or meow. You can also carry a small squeaker toy, and tuck it between your camera and right thumb. If that is too cumbersome, shop for whistle-like toys that make a variety of sounds. You can hold them in your mouth and still keep both hands on the camera.

Light & Lighting Techniques

Except for the subjects of your portraits, the type of light you use is the single most important aspect when making pictures of people. Light can make a person look beautiful or ugly. It can add excitement and drama, or set a mood. And it can accentuate or hide the features of a person's face.

To understand how to use light for better portraiture, you need to understand that light has certain qualities. These qualities include hardness or softness, direction, and color. These qualities can be found in natural light, household lighting, on-camera flash, and studio lighting kits.

5.1 Hard Vs. Soft Lighting
Which is Better for Portraits?

Tools:

- Hard or soft lighting
- Dappled light

Hard or Soft Lighting

First and foremost, light can be described in terms of its hardness or softness. Hard light produces hard-edged, dark shadows. Soft light produces soft-edged shadows that are less dark. Extremely soft light can be almost shadowless.

Direct sunlight (below) creates deep, dark, and hard-edged shadows. This is not usually your best choice for portraiture.

Soft light (right), usually results in the most pleasing portraits. Good examples of soft light are open shade or north-facing windows. Soft light produces soft-edged shadows that are much lighter than those produced by hard light.

Lens Focal Length: 40mm
Aperture: f/9
Shutter Speed: 1/60 second
ISO: 100
Metering: Matrix

Notice how much easier it is to see the details in this man's face when he is photographed under softer lighting (above) compared to direct sunlight (top).

did u know?

Window light has been used for portraiture since long before the advent of photography. Master painters posed their subjects in front of north-facing windows for attractive, soft lighting.

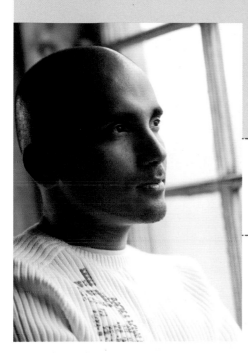



Tip

Window light can be very attractive. Pick a window that gets soft, indirect light (no direct sunbeams). This can be a north-facing window or a window that has a roof overhang. Beware of windows that have too large an overhang or trees blocking the light, because this might result in too little light reaching your subject.

The tricky part is positioning yourself so you can photograph the person with the light hitting them from a front or 45° angle. (See pages 92, the Direction of Light). Usually this means you are squeezing up next to the same wall as the window and shooting toward the inside of the room.

Lens Focal Length: 100mm
Aperture: f/2.8
Shutter Speed: 1/320 second
ISO: 100

Bright sunlight on a clear day is the best example of hard light. It travels directly from the source to the subject. At its best, a portrait shot in bright sunlight will have rich colors and deep, dark shadows that can accentuate shapes and textures. These factors combined can make an ordinary picture seem bolder and more graphic. At it's worst, it can look harsh and accentuate skin imperfections.

This dramatic portrait uses a single, direct source of light to create hard shadows that sculpt the face.

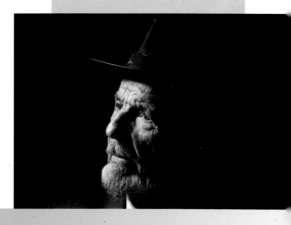

Outside, should the clouds roll in, direct sunlight will have to pass through them to reach your subject. This diffuses the light and makes it softer, striking the subject from a number of different angles. The heavier the cloud cover, the softer the light. Shadows now become softer, and details on the shadow side are now visible. Shade has a similar effect.

In general, soft light produces the nicest, most complimentary portraits. There are, of course, exceptions. You can take great portraits in bright sunlight. It's just a little more difficult and yields a different result. I usually advise that you start with soft lighting. Move into the shade or shoot on days that are slightly overcast.

Even soft lighting can create unpleasant shadows (top left), especially under the eyes. If you see this happening, try and come up with a pose in which the person is looking toward the light, such as the raised head (above). Alternately, add fill-flash (see page 100).

Dappled Light

Watch out for the dappled effect where uneven patches of light and shadow show up

Dappled lighting can cause distracting highlights.

Exposure Mode: Auto
Lens: 45mm
Aperture: f/4.5
Shutter Speed: 1/400
ISO: 200

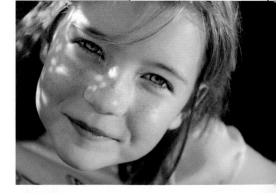

on your subject's face. This is caused when the light source is partially obstructed.

Because our eyes are drawn to the brightest part of any picture, this can focus undesired attention to the wrong places. For the best results with dappled light, try to place the eyes or other important features of the subject in the brightest light. This is because the viewer will be attracted first to the highlights in a picture—and it is usually best if you are attracted to the subject's eyes.

At left, the sun striking this model's face has created a highlight on her nose that draws attention away from where we want it: her eyes.

Turning the model so that much more of her face is in shadow eliminates the highlight on her nose (bottom left).

Now, moving our model entirely into the shade (bottom right) evens the lighting and eliminates the dappling effect altogether.

5.2 The Color of Light
from Warm to Cool Colors

The Color of Light

In addition to hardness or softness, the light's color has a big impact on a portrait. Every source of light has its own hue, or color temperature. It is important to look carefully at the light, and recognize unusual, non-neutral colors.

In some situations, you may like the way a color cast looks, such as golden light (right) in the late afternoon or cool blue tones of sunrise and twilight. At other times, you may want to neutralize (eliminate) the color cast through white balance controls (page 134).

Exposure Mode: Manual
Lens Focal Length: 50mm
Aperture: f/4
Shutter Speed: 1/160

Lens Focal Length: 76mm
Aperture: f/5.6
Shutter Speed: 1/100
Equivalent ISO: 100

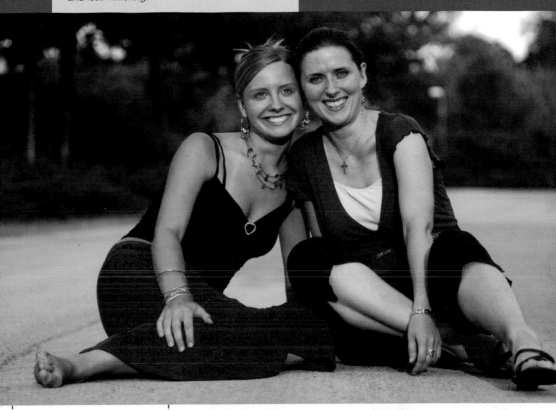

Lens Focal Length:
80mm
Aperture: f/2.8
Shutter Speed: 1/400
ISO: 160
Metering: Matrix

Lens: 80mm
Aperture: f/3
Shutter Speed: 1/200
ISO: 160
Metering: Matrix

5.3 The Direction of Light
with Close-Up Photography

The Direction of Light

We can't control the sun, but we can control what time we shoot and how we position our subject relative to the sun. And with other types of light, such as flash, household bulbs, studio lights, or even candlelight, we have a lot of control, particularly in determining at what angle the subject will be illuminated by our light source.

Tools:

- The direction of the light
- Front light
- 45° light
- Side lighting
- Back and rim lighting
- Specialty lighting

Lens Focal Length: 36mm
Exposure Left: f/4 and 1/200
Exposure Below: F/8 and 1/500
ISO: 100
Metering: Matrix

The subject's position in relation to the light source makes a huge difference in how the portrait looks. At sunset, with the sun to the right, the woman's face is lit (above). But when the boat turns and the sun is behind her, we now have a silhouette.

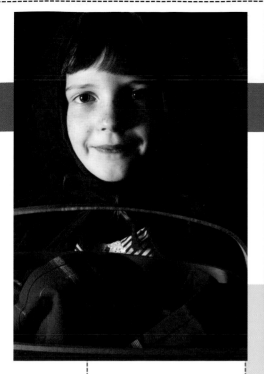

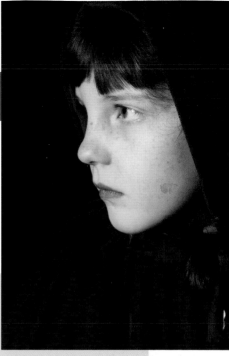

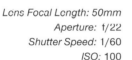
Lens Focal Length: 50mm
Aperture: f/22
Shutter Speed: 1/60
ISO: 100
Metering: Evaluative
Lighting: Remote Flash

Side lighting can cause odd shadows on a person's face. Having the model turn into the light eliminates the shadows.

For example, look at the Little Red Riding Hood portraits above. In one picture, the girl is looking at the camera, and the side lighting causes highlights and shadows on her face. In the upper right portrait, the girl is looking into the light in the left photo, so we do not see shadows on her face. This is far more pleasing than the portrait with shadows. It is important to note that light did not change. However, the model moved in relation to the light.

Different directions of light will create different effects in your photograph.

FRONT LIGHT: If the light is coming from behind the camera and is at the same height and direction as the camera lens, then the lighting will be "flat" because the shadows are not visible (whether it is hard or soft lighting). A variation is high front, which will cast a shadow under the subject's nose in a portrait.

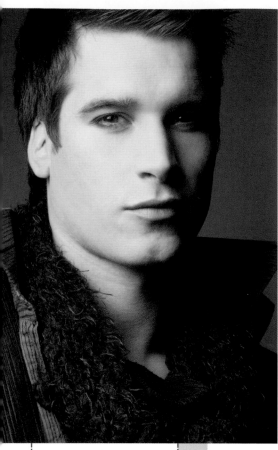

45° LIGHT: Move the light 45° off the axis of the camera, and the shadows will fall to the side and become more visible to the camera.

SIDE LIGHTING, FACING CAMERA: With the lighting from the side, you may see strong shadows if the model is facing the camera.

SIDE LIGHTING, FACING LIGHT: If the lighting is from the side, you can have the model face the light and photograph their profile.

BACKLIGHT: Move the light directly behind your subject and you have backlighting.

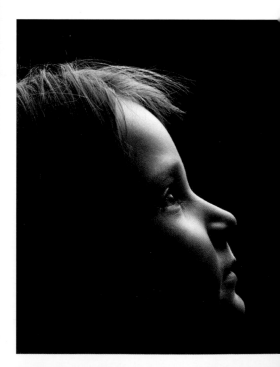

Lens Focal Length: 72mm
Aperture: f/10
Shutter Speed: 1/40
ISO: 400
Metering: Partial

A 45° angle is a classic portrait light. The goal of this technique is to create a triangle of light on the cheekbone of the far side of the face. The light should hit the far eye as well.

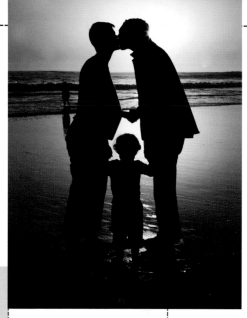

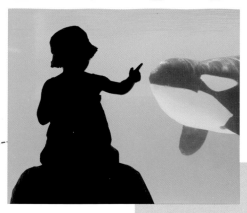

Lens Focal Length:
50mm
Aperture: f/4.5
Shutter Speed: 1/250
ISO: 100
Metering: Evaluative

Backlighting without any front fill light will produce a silhouette.

Lens Focal Length:
58mm
Aperture: f/22
Shutter Speed: 1/200
ISO: 200
Metering: Evaluative

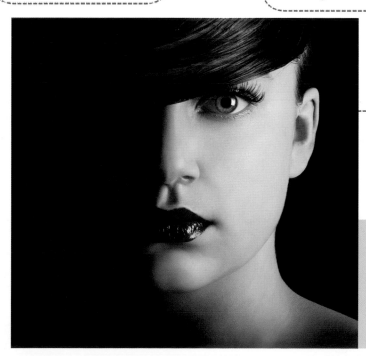

Lens: 50mm
Aperture: f/10
Shutter Speed: 1/250
ISO: 100
Metering: Evaluative

Side lighting can be very dramatic, but it takes a fine touch to compose a side-lit picture well, because of the strong shadows it causes.

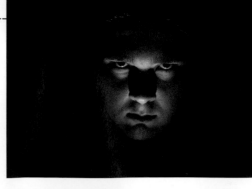

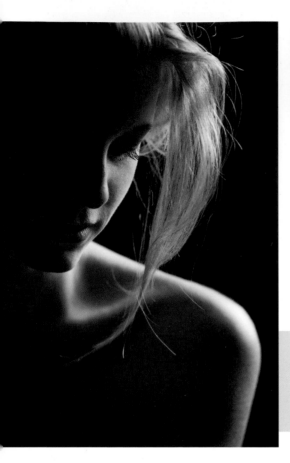

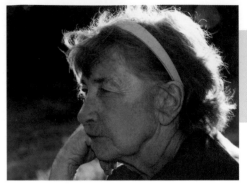

Side lighting can be used dramatically to "sculpt" the shape of your subject. When the side light is a single source, and the background is black, it can be an especially effective technique.

Tip

Candlelight may be dim, but it is quite beautiful. Today's cameras have excellent low-light capability and can achieve wonderful results. Be aware that your camera may want to use the flash. If you want only the candle to light the scene, make sure you use the flash-off setting on your camera.

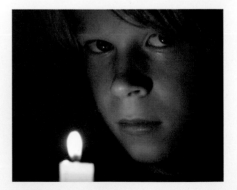

The sun never shines from below, so the lighting at left looks unnatural and is the classic "horror movie" lighting.

Exposure Mode: Manual
Aperture: f/13
Shutter Speed: 1/250
ISO: 100
Metering: Evaluative

This portrait would have been a backlit silhouette if the photographer had not added flash to illuminate her face.

BACKLIGHT WITH FILL: If you don't want a backlit portrait to become a silhouette, you can add fill light with a flash or reflector. Alternately, you can increase the exposure using plus exposure compensation. This will result in a properly exposed face, but the background may become too bright.

RIM LIGHT: Rim lighting is when the light source is slightly to the side and behind, creating an outline of light.

BOTTOM LIGHT (HOLLYWOOD HORROR): This type of lighting is not usually found in nature, so it looks "odd" for portraiture. Because of this, it is a favorite of directors who make horror movies.

SPOTLIGHTS: A hard directional light at night immediately evokes "theatre" if high, and "car headlights" if low.

Improving Sunny Portraits

The sun can create harsh shadows on your subject's face, especially at noon when the sun is at a high angle. Here are four ways to improve your sunny portraits:

1. Put the sun at your back, so your subject is lit from the front. However, you may still get harsh shadows on their face and squinting eyes.

2. Position the subject for creative use of the highlights and shadows, such as rim light or other techniques shown in this section.

3 Move into the shade for softer light that eliminates harsh shadows.

4. Wait until the angle of the sun is lower in the sky than "high noon" (afternoon, early morning, or winter).

5. Add fill flash. The subject can even wear a brimmed hat to reduce squinting, while the fill flash will light the dark shadow area under the brim. (More on that on page 100).

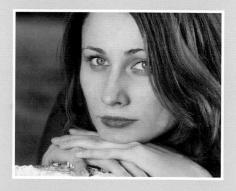

5.4 Using Flash & Flash Modes
to Enhance Your Portraits

Many people think of electronic flash as simply a way to supplement the available light in a scene. They don't realize that flash is a useful tool that will improve their photos, even brightly lit outdoor portraits. When used properly, flash can take photography from mediocre and blah to exciting and compelling.

Most cameras have built-in flash units, but these vary greatly in their capabilities. How these flash units function and their controls for lighting a scene also vary widely. These features are largely dependent upon the type of digital camera in use. Keep in mind when reading the descriptions in this chapter that these are generalizations and your camera and flash may work slightly differently.

Most cameras that have a built-in flash also have an auto flash mode in which the camera automatically fires the flash when it senses there is not enough light for a good exposure, and in some cases when the camera detects a backlit situation.

Tools:

- Flash basics
- Fill flash
- Force flash
- Night flash
- Flash off

When your subject is backlit, flash will help you produce a properly exposed subject.

Exposure Mode: Auto
Lens Focal Length: 168mm
Aperture: f/4
Shutter Speed: 1/800
ISO: 800
Metering: Evaluative
White Balance: Auto (AWB)
Subject Distance: 2.8 m (9.2 ft)

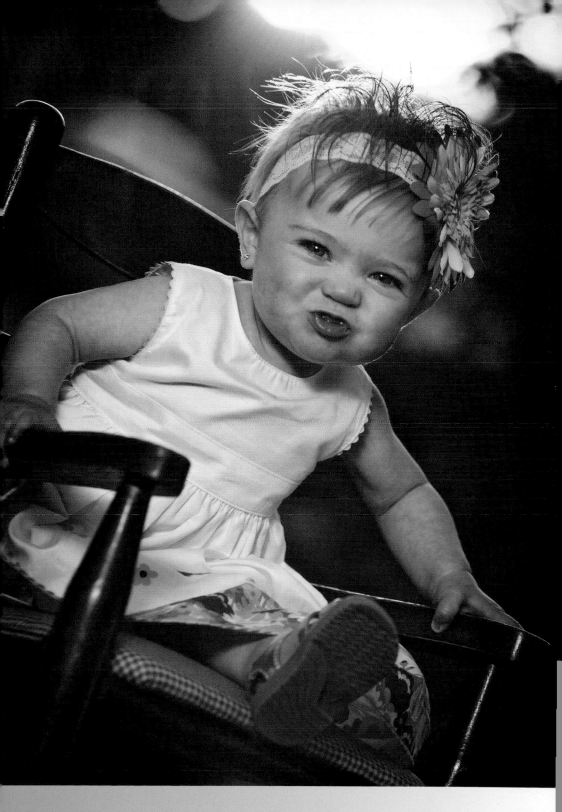

This produces adequate results in most circumstances. However, there are a number of situations when you will want to take control of your camera's flash modes to produce the best pictures. These modes may include Fill Flash, Force Flash, Night Flash, and Flash Off.

The Wonders of Fill Flash

These various flash modes give you some creative control if you choose to use them. One of the most useful is Fill Flash mode. The best use of fill flash is when you are photographing people outside on very bright, sunny days.

Tip Auto Flash: The sunlight causes unpleasant lighting under the brim of the hat. Full auto flash makes the flash the primary light source, and it can actually overpower the sunlight, and cause the more distant background to go dark. Using fill flash (next page) will result in a more natural look.

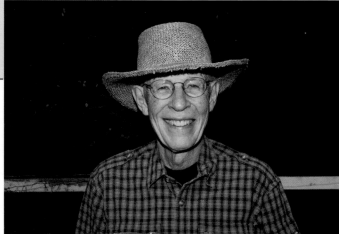

Exposure Mode: Auto
Lens: 70mm
Aperture: f/8
Shutter Speed: 1/200
ISO: 100
Metering: Evaluative
No flash in top version:
Full (Force) Flash in near
right version.

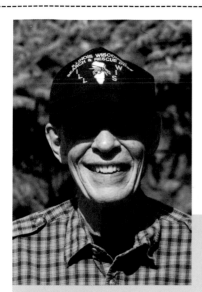

Fill-Flash: A brimmed baseball hat in direct sunlight causes dark, unpleasant shadows on the subject's face. Fill flash will lighten these shadows without overpowering the natural sunlight. This usually achieves more natural results if brightening the shadows is your goal.

Exposure Mode: Aperture Priority
Lens Focal Length: 200mm
Aperture: f/16
Shutter Speed: 1/200
Metering: Evaluative
No flash in left version; fill-flash (at exposure of -1.5 EV under daylight) in the right version.

While it may seem strange to add more light when there is already quite a bit, fill flash actually evens out the light, reduces the overall image contrast, and makes colors pop. This is because it reduces the overall contrast by lightening the darker shadows.

The classic example of when to use fill-flash is a person wearing a baseball cap or other brimmed hat, and the shadow beneath it hides the details of the face.

Using Force Flash in a shady situation (left) or backlit situation (above) will make the subject "pop" out of the background and prevent a silhouette. The flash becomes the main light, though the background, which is lit by ambient light, is also recorded.

Exposure Mode: Auto
Lens Focal Length: 135mm
Aperture: f/5.6
Shutter Speed: 1/500
Exposure Compensation: +0.33
ISO: 100
Flash: Full (Force)

Lens Focal Length: 118mm
Aperture: f/6.3
Shutter Speed: 1/200
ISO: 400
Metering: Evaluative
Flash: Full (Force)

Fill Flash mode works because the flash is set to a level that is weaker (less bright) than the non-flash illumination (usually the sun). So instead of eliminating the shadows, it simply lightens them. This makes the picture seem like it is lit with natural light, yet you can see details in what would otherwise be dark shadows.

Force Flash Mode

With Force Flash mode, the flash tries to deliver enough illumination so that it becomes the main light source. This differs from Fill Flash, in which the flash is meant only to fill in shadows and not become the main light. The classic situation for using Force Flash is when

your subject is positioned so he or she is lit from behind, and the background is much brighter than the face (a backlit situation). Shooting without flash would probably yield a complete or partial silhouette, with the person so dark that you can't see any features.

Force Flash can also be used to brighten the subjects in comparison to the natural light. This tends to make your subjects "pop" out of the scene, therefore making them more dominant elements in the picture.

Night Flash

Night Flash mode is an excellent choice when shooting portraits at sunset, in front of a nighttime cityscape, or in low light situations. This combines flash with a longer exposure so that the background, which is

Without flash, this picture would either be a silhouette against the sunset or a well-exposed girl with a washed-out sky behind (depending on your exposure). Note that a remote flash was used, so it could be positioned off-camera and to the right for more directional lighting.

Lens Focal Length: 17mm
Aperture: f/8
Shutter Speed: 1/60
ISO: 100
Metering Mode: Pattern
Flash: Night Flash (Slow Synch)

Since the photographer was also on this ride, the kids were not moving in relation to the camera. Night Flash lit the subjects while the background spun into a fast-moving blur.

Exposure Mode: Manual
Lens Focal Length: 52mm
Aperture: f/8
Shutter Speed: 1/160
ISO: 200
Metering Mode: Center-Weighted
Flash: Remote (Off-Camera)
White Balance: Manual, 5700K
Brightness: +50
Contrast: +25

Which Flash Mode Should I Use?

DISTANT SUBJECTS:

Your flash can't light up a distant player at a baseball stadium. For distant subjects, select Flash Off and hold the camera very steady (or use a tripod). If you are using a D-SLR camera, you can add an accessory flash, which will be more powerful than the camera's built-in flash.

CLOSE-UP SUBJECTS:

If a close subject is too brightly lit by flash, it may be because your flash cannot "power down" enough for proper exposure. Select Flash Off and hold camera very steady (or use a tripod).

OUTDOOR, BRIGHT AND SUNNY:

You may want to lighten shadows on your subject's face that are caused by sunlight, such as the shadow caused by a baseball hat. Select Fill Flash to lighten these shadows, without over-powering the natural light.

BACKLIGHTING, SILHOUETTE:

If your model is posed against a beautiful sunset or bright lights and you want a silhouette, select Flash Off and hold camera very steady (or use a tripod).

BACKLIGHTING, NO SILHOUETTE:

If your subject is in front of a colorful sunset or bright city lights at night and you want to see both the colorful background *and* your subject's face, select Night Flash (sometimes called Slow Sync).

ELIMINATE RED EYE:

If you shoot in dim lighting, the built-in flash on your camera may cause the ugly red-eye effect. Red-Eye Reduction mode can reduce it. Accessory flash units on DSLR cameras can eliminate it altogether.

SOFTER LIGHTING:

If your flash pictures look a bit harsh, you might want to add an accessory flash to your D-SLR camera. These powerful flash units can be bounced off the ceiling to soften them. Alternately you can add a reflector, diffusion box or other accessory designed to soften the flash unit's illumination.

not illuminated by the flash, will record on the sensor. Consequently, instead of getting a pitch-black background, you will record the sunset, city lights, or other scenery behind the subject.

If your background moves during a photograph taken with night flash, you can get wonderful, creative effects. The flash freezes the nearby subject, while the background blurs. Examples include a roller coaster ride, a playground spinner, or nighttime traffic behind your subject.

Backlighting occurs when the background is much brighter than the light on the subject's face, such as a person standing in front of a window or a sunny sky. If you don't supply light to illuminate the front of the subject, you may end up with a silhouette.

Exposure Mode: Auto
Lens Focal Length: 210mm
Aperture: f/5
Shutter Speed: 1/560
Metering Mode: Partial
ISO: 100
Flash: Full (Force)

5.5 Accessory Flash

for Added Capability on D-SLR Cameras

Accessory Flash

One of the best things about a D-SLR camera is that it will accept accessory flash units. These can be attached to the top of the camera or operated remotely through a cord or wireless connection.

Accessory flash units have several advantages:

1. They have a separate power supply and are more powerful than built-in flash units.

2. They recycle faster so there is little delay between pictures.

3. Most can be tilted, so they can be bounced off the ceiling or reflectors for softer effects.

Tools:

- Advantages of accessory flash
- Bouncing or diffusing the light
- Off-camera flash capability

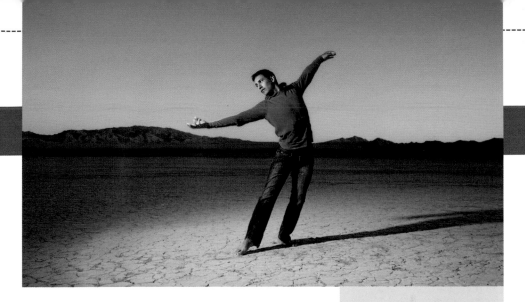

A remote flash placed to the side gives dramatic lighting that fits the sunset scene.

4. Most can accept accessories that make the light softer and more pleasing.

5. Many can be used "off camera" with a dedicated cord or wireless system. This produces more pleasing light for portraits because the flash is not directly over the camera.

If you invest in an accessory flash for your D-SLR camera, be sure to select one that is

Accessory flash units can be softened with diffusers and reflectors, or bounced off a white ceiling. The result is soft, beautiful lighting.

Exposure Mode: Auto
Lens Focal Length: 200mm
Aperture: f/4
Shutter Speed: 1/160 second
ISO: 200
Metering: Spot
White Balance: Manual, 4550K

dedicated to your digital camera model. This means it will communicate well with the camera's exposure and focusing systems, which results in better pictures.

Advanced flash units often have flash heads that can be tilted to direct the light at different angles. Pointing the flash towards the ceiling or into a reflector card will create bounce lighting, which is softer and more pleasing for most portraits.

Some accessory flash units can be removed from the top of the camera and fired remotely. This allows you to place it at a different angle, such as the side or high front lighting discussed on pages 92-97. Some can even be set to "sync" together to create a studio-style multi-light setup.

Advanced Techniques

I n addition to the composition, posing, and lighting tips presented in the previous chapters, there are some advanced techniques you can utilize to get even more control over your portrait photographs.

If you own a D-SLR camera, you'll have some advantages over other photographers. For starters, it can accept a wide range of professional accessories, from flash units (see pages 98-109) to specialized lenses. It also has advanced capabilities that not only improve the quality of your pictures, but also give you creative control of exposure, focus, and white balance. This will allow you to artistically alter the way the picture is rendered.

All photographers can have fun with their pictures in the computer. Photo editing software has become less expensive to buy and much easier to use. You can go from a few small changes in the color and cropping, to total artistic creations that combine multiple photos, text, and more.

6.1 Lenses & Focal Lengths
Can Change the Feel of the Picture

Tools:

- Types of lenses
- Focal lengths & distance
- Subtle distortions
- Size relationships

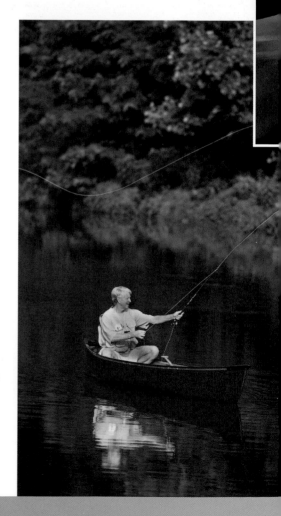

Lenses

Throughout this book I have talked about zooming from wide to telephoto focal length settings for specialized artistic effects. If you own a D-SLR, your camera will accept a broad range of accessory lenses with different advantages and capabilities.

Fast lenses with large maximum apertures of f/2 or f/2.8 allow you to shoot in dim light. Super wide-angle lenses give you the option of shooting large groups in shallow spaces, show a lot of the background, or add creative perspective exaggerations to your pictures. And when using super-telephoto lenses, you can shoot frame-filling portraits from a distance. This is great for candids, and often renders the person's features attractively.

These two portrait have similar subjects. The top image was shot with a wide angle lens (low-number focal length such as 17mm), and shows a wide view with a lot of the surrounding scenery. It is such a wide angle of view, that the front of the photographer's kayak is visible.

The image at left was taken at a great distance with a telephoto lens (a high number focal length, such as 300mm).

Exposure Mode: Auto
Lens Focal Length: 17mm
Aperture: f/9
Shutter Speed: 1/160
ISO: 100
Exposure Compensation: +0.70
Metering: Pattern
White Balance: Auto

Lens Focal Length: 300mm
Aperture: f/4
Shutter Speed: 1/1000
ISO: 100
Metering: Center-weighted
White Balance: Custom, 6100K

All-in-one zoom lenses cover everything from wide to telephoto in one handy package, so you don't need to carry extra lenses. Macro or close-up lenses allow you to focus at closer than normal distances, such as shooting a portrait that just includes a partial face. Specialty lenses can add soft-focus effects.

And the Lensbaby® series of lens modifiers can add interesting blur effects.

Most people shoot portraits with a wide angle lens or lens setting out of habit, and from a fairly close distance to their subject. This is a great choice if you want to show your subject in a wide expanse of nature, such as the kayaking picture on the previous page.

However, this is rarely the best way to shoot classic portraits, because wide angle portraits at a close distance can cause distortions.

If you use a super wide lens and get really close, you can take this distortion to extremes like the picture below. The result can be funny or cute, which is great fun for Halloween pictures. And if the head is closest to the

All lenses cause distortion which you can use to your advantage (or disadvantage). A wide angle, like 19mm (right) can cause comic distortions if you are near to your subject. A telephoto, like 130mm, can cause a a distant mountain background to appear larger and closer than it is in reality.

Exposure Mode: Manual
Lens Focal Length: 19mm
Aperture: f/10
Shutter Speed: 1/30
ISO: 100
Metering: Spot
White Balance: Manual, 5900K
Exposure Compensation: +0.85

Lens Focal Length: 80mm
Aperture: f/7.1
Shutter Speed: 1/320
ISO: 100
Metering: Center-Weighted
White Balance: Manual, 5800K

lens (such as looking down at a child or dog,
see page 37), that is what will appear out of
proportion. This can give an adorable baby
or puppy-face look to the picture.

Subtle Distortion

If you stand close to your subject using a
wide-angle lens or a zoom at a short focal
length, you will get less distortion, but it will
still be there. Often this distortion is so subtle
that you can't detect it unless you're really
looking for it. But it is there, and it will change
the perception of the picture. Rarely is this
the most flattering rendition of your person.

Instead, you will usually get much more
pleasing results by zooming your lens all the
way to the telephoto setting (such as 200mm
on an 18-200mm lens), and stepping back to
compose at this setting. The reason involves
complex optical science, but in practical
terms, it flattens out the features in a natural
and complimentary way.

Some cameras (and D-SLR lenses) have in-
credible telephoto capabilities. This means
you can magnify the subject in the view-
finder to a great degree. It also means you'll
need to step much farther back from your
subject than you're used to doing. It is not
uncommon to be 30 feet (9 meters) away
from your subject when taking a beautiful
telephoto portrait.

Tip

Most people's first instinct is to
shoot portraits from a few feet
away. Stepping much further
back and zooming in to a tele-
photo lens or lens setting (right,
200mm focal length) is much
more flattering than shooting
from close range with a wide
angle lens (18mm, below).

Exposure Mode: Aperture Priority
Lens Focal Length:
200mm (right), 18mm (below)
Aperture: f/4
Shutter Speed: 1/400
ISO: 200
Metering: Center-weighted
White Balance: Cloudy
Exposure Compensation: -0.33

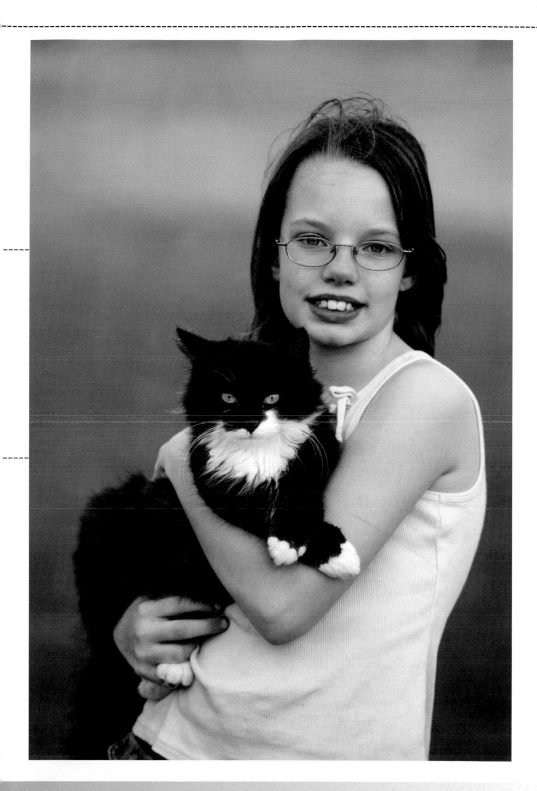

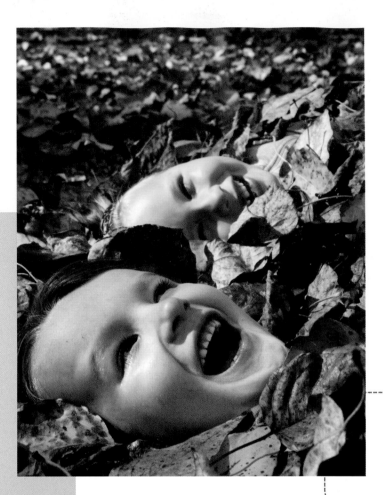

When shot at an equal distance from the lens, both of the children's faces are the same size (far right). But put them at different distances and get in close using a wide-angle setting, and suddenly their relative sizes are radically different!

This same effect can be used to emphasise the father-son size difference in the photo below.

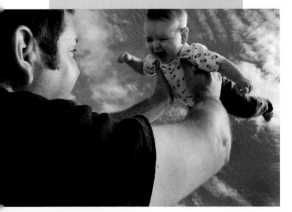

Size Relationship

As we learned earlier, a portrait taken with a wide-angle lens setting can cause distortions by making the closest portion of the picture look disproportionately bigger (see page 37). However, the same quality can be used to improve a picture. In the example at left, a father is helping his baby son "fly."

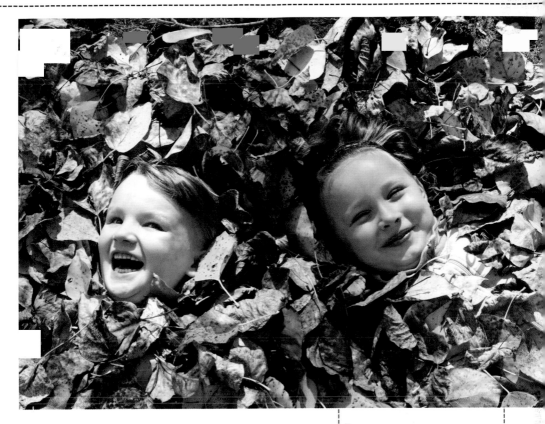

Lens Focal Length:
18mm
Aperture: f/3.5
Shutter Speed: 1/280
ISO: 80
Metering: Pattern

Lens Focal Length:
16mm
Aperture: f/3.3
Shutter Speed: 1/280
ISO: 80
Metering: Pattern

Because the photographer moved in close to the father with a wide-angle lens setting (such as 18mm on a D-SLR camera), placing the child farther away, their size relationship is distorted in a way that improves our enjoyment of the picture. The closer you get to the foreground person, the greater the difference in size.

In the autumn leaves example, when the children are equidistant to the camera, their faces are the same size. But move one closer, and this size relationship changes drastically. This can be a good thing or a bad thing, depending on your composition. The important thing to remember is that you can control it by your lens choice and shooting position.

6.2 Understanding Exposure

Apertures & Shutter Speeds

Controlling Exposure

Getting the perfect exposure is an advanced topic. But the basic concept is simple: Exposures are made when the camera allows light to enter the lens and record on the digital imaging sensor. A certain amount of light is needed to make the proper exposure in any given situation for a certain subject.

Tools:

- Controlling exposure
- Aperture priority
- Shutter priority
- Exposure compensation
- Manual exposure

A fast shutter speed is needed to freeze the motion for tack-sharp action pictures.

Lens Focal Length: 155mm
Aperture: f/5
Shutter Speed: 1/400
ISO: 320

A wide aperture (low-number f/stop like f/2.8 or f/5) will cause the foreground and background to be softer than the same photo with a narrow aperture like f/16. Than help emphasize your subject.

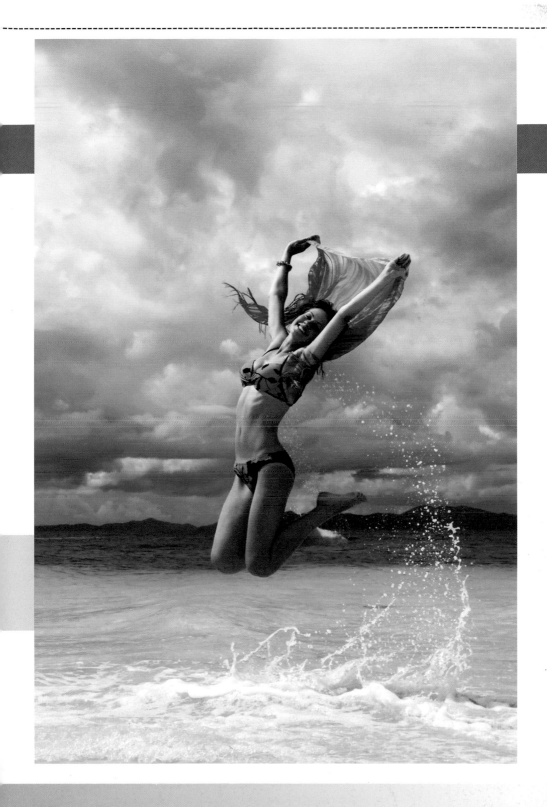

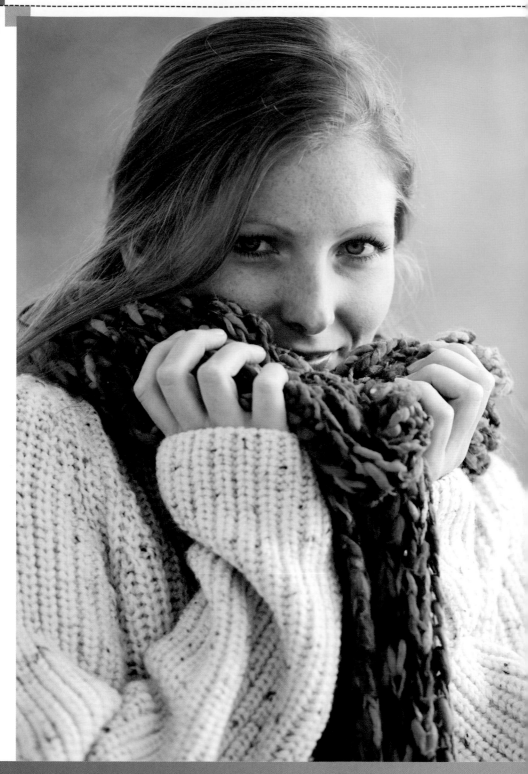

How the camera gets just the "right" amount of light is one of the creative aspects of advanced photography. The amount of light can be controlled in three basic ways:

1. APERTURE: This is the size of the opening in the lens, and is expressed in an f/stop such as f/4. The aperture only allows a certain amount of light to strike the imaging sensor. It also affects how much of the scene (from foreground to background) is in sharp focus.

2. SHUTTER SPEED: This is the length of time the shutter is open. Shutter speed not only allows light to strike the sensor for a certain length of time, it also affects how sharp or blurry the picture is due to camera shake, subject movement, or both.

3. EQUIVALENT ISO: The ISO setting adjusts the camera's response to light. At higher ISO settings, the sensor's output is amplified to be more sensitive to light. However, higher ISOs also degrade the picture quality. Whenever possible, use lower ISO settings. See page 130 for more about selecting ISO settings.

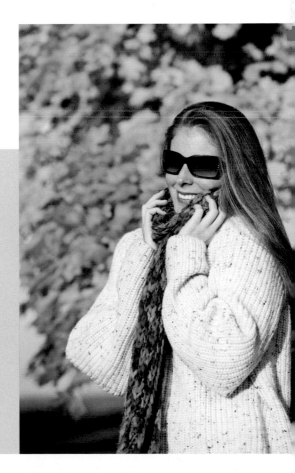

Wide apertures can soften the background, so the subject stands out. This can be a slight softening, such as the photo at right where you can distinctly see the autumn leaves. In the version at left, the leaves are so out-of-focus they are simply blurred orange.

How sharp or soft your background looks is effected by three major factors:

1. Wide apertures cause softer backgrounds.

2. Selecting a lens or lens setting with a higher number focal length (such as 200mm) will cause a softer background than a similarly composed picture with a lower number focal length.

3. Moving your subject further away from the background (and moving backwards to keep the subject the same size in the picture) will cause a softer background.

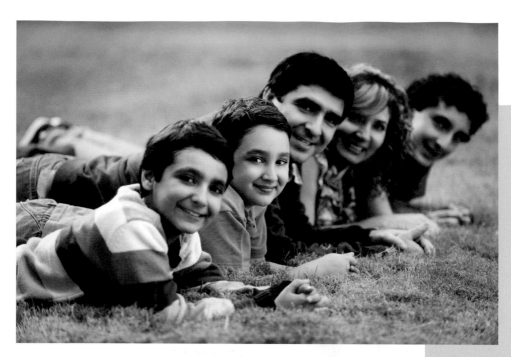

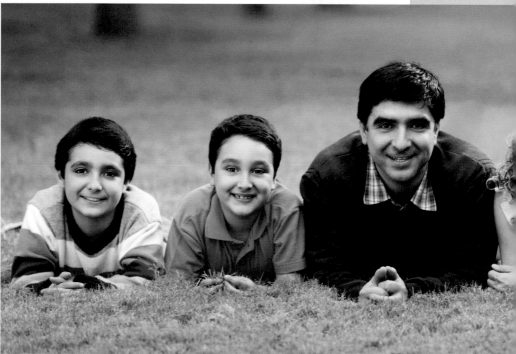

On the previous page, we showed how a wide aperture can improve a portrait by creating an out-of-focus background. However, when your subjects are at different distances from the camera, a wide aperture can cause some of the people to be soft (left).

You can avoid this by selecting a much narrower aperture (high number f/stop, such as f/16). Another solution is to change the composition so the subjects are all equidistant from the camera (below).

Aperture Priority Mode (A or Av)

If the depth of field (how much of the scene is in acceptably sharp focus from foreground to background) is most important for your photo, select your preferred aperture using this exposure mode on your camera. When you pick your preferred aperture in A mode, the camera automatically chooses the appropriate shutter speed for proper exposure.

If you want to emphasize your subject by placing the background out of focus, select a large f/stop (small f/number) such as f/2.8 (if possible) or f/4.

If you are photographing multiple people who are at different distances from the camera, select a small f/stop (large f/number) such as f/11 or f/16.

Both Images:
Exposure Mode: Manual
Lens Focal Length: 120mm
Aperture: f/2.8
Shutter Speed: 1/125
ISO: 200
Metering: Matrix
White Balance: Cloudy

Exposure Mode: Auto
Lens Focal Length: 63mm
Aperture: f/8
Shutter Speed: 1/30
ISO: 50
Metering Mode: Evaluative

Lens: 40mm
Aperture: f/10
Shutter Speed: 1/13
ISO: 500
Metering Mode: Spot
White Balance:
4500K

In the top photo, the shutter speed is too slow (1/30 sec.), so the bicyclist blurs to the point she almost disappears. A higher shutter speed (1/320 sec.) freezes the bicyclists in the middle photo. And panning with a slow shutter speed creates an artistic picture in which the bicyclist is relatively sharp, and the background is blurred.

Panning your camera can help you get better pictures of moving subjects, even at slower shutter speeds. To pan the action, track the subject in the viewfinder before, during, and after you push the shutter button. If you do it smoothly and at the right speed, the subject will look relatively sharp and the background will be a smooth blur.

Shutter Priority Mode (S or Tv)

In Shutter Priority mode, instead of picking the aperture, the photographer selects a preferred shutter speed, and the camera chooses the aperture for the proper exposure.

If you are shooting a moving subject and the amount of blur (or absence of blur) is most important, select your preferred shutter speed using this exposure mode. A shutter speed of 1/500 is faster than 1/50, so it has better action-stopping capability.

Exposure Mode: Manual
Lens Focal Length: 24mm
Aperture: f/8
Shutter Speed: 1/320
ISO: 500
Metering Mode: Evaluative
White Balance: 5500K

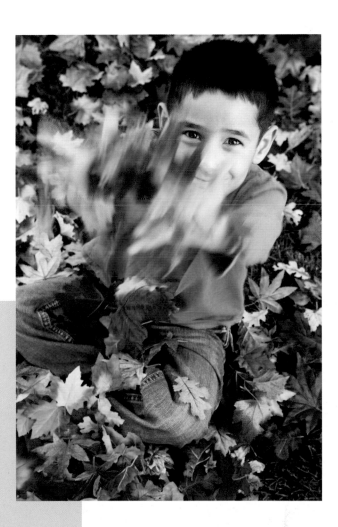

Use a fast shutter speed for most action pictures. However, if you want to create an artistic blur select a slower shutter speed.

A shutter speed of 1/60 second was fast enough to freeze the relatively stationary boy. However, the tossed leaves were moving quickly and blurred at this slow shutter speed.

Manual Exposure Mode (M)

With a D-SLR you can also switch to Manual Exposure mode. In this case, you select both the aperture and the shutter speed. To use M mode effectively, it helps if you have a basic understanding of exposure. If not, you can easily under or overexpose the subject and ruin your pictures. However, making mistakes in Manual mode is sometimes a good way to actually learn the basic relationships between aperture, shutter speed, and

ISO, as long as you try to figure out why an exposure did not work. With digital, it is a simple matter to experiment and delete those image files that result in poor exposure. Most D-SLR cameras will show a display in the edge of the viewfinder that indicates whether the camera thinks the exposure you have set is too much or too little.

It can be difficult to properly expose pictures that have a lot of dark tones in them because the camera may overexpose the picture. If this happens, your picture will look murky or bluish. Review pictures on your LCD monitor and if you see this happening, use minus exposure compensation (-EV), as done with this photo.

Pictures that have a lot of white in them can sometimes fool a camera into underexposing. If this happens, your picture will look murky or bluish. You can improve your exposure, as done here, by using plus exposure compensation (+EV) and reshooting.

Exposure Mode: Manual
Lens Focal Length: 200mm
Aperture: f/3.5
Shutter Speed: 1/200
ISO: 100
Metering: Matrix
White Balance: 5200K

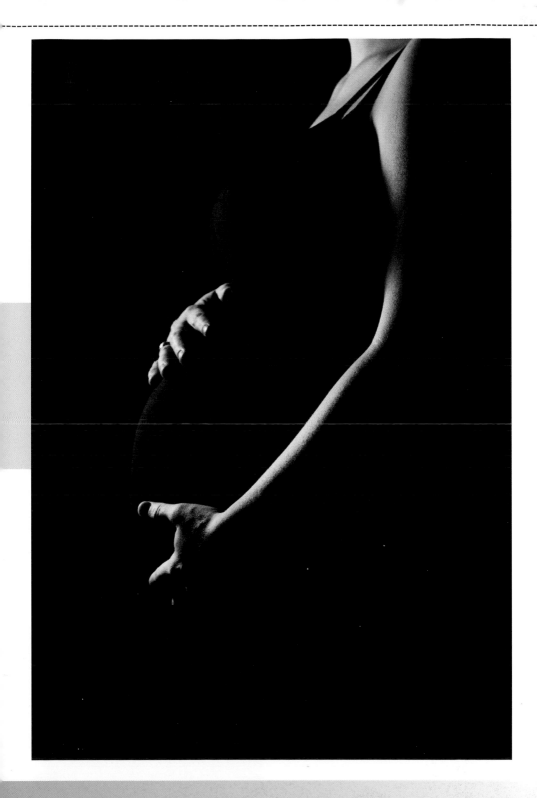

6.3 Equivalent ISO

You may be shooting with a digital camera, but the concept of "film speed" hasn't disappeared. It is now known as Equivalent ISO (generally referred to simply as ISO), and it lets us adjust the low-light capability of the camera.

As the light gets dimmer, it becomes harder for your camera to deliver action-stopping shutter speeds. It also limits the camera's ability to keep everything in acceptably sharp focus from foreground to background, due to a phenomenon called depth of field that is affected by the lens aperture. Raising the ISO can help your camera get faster shutter speeds and more depth of field.

However, there is a corresponding drop in quality at higher ISO settings in terms of noise, contrast, and color. So you don't want to raise the ISO unless absolutely necessary for the reasons mentioned above.

The list below will help you select the right ISO setting for a given situation:

SUNNY DAYS: Use auto or low ISO settings.

DIM LIGHTING & ACTION: If you are getting blurry picture, switch to a higher ISO setting or add flash (see pages 97-109).

MORE IN FOCUS: If you want as much in focus from foreground to background as

A high ISO setting allows you to shoot in dimmer lighting. Today's camera have amazing low-light capability.

possible, switch to a higher ISO setting or use your Landscape mode (if your camera offers it).

LESS IN FOCUS: If you want a portrait to have a blurry, less distracting background, switch to lower ISO setting or to Portrait mode.

PICTURES TOO DARK: Switch to a higher ISO setting, turn on your flash (see chapter 5), or use exposure compensation (pages 132).

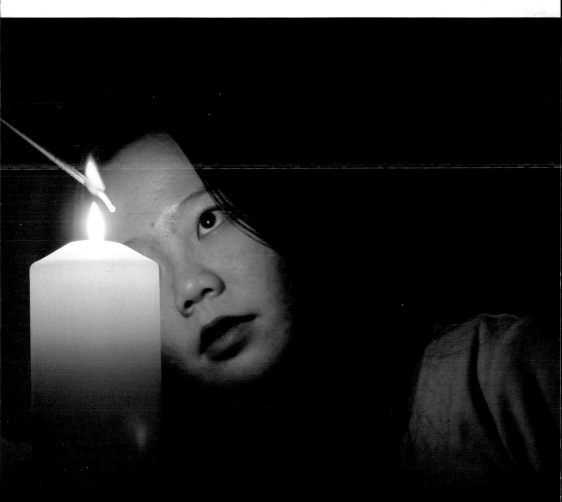

6.4 Exposure Compensation
for Especially Dark or Light Subjects

No camera is perfect, and occasionally yours may get fooled by a tricky lighting situation, or an especially light or dark subject. Most D-SLR cameras, and a few point-and-shoot cameras, have an exposure compensation option, which is usually indicated by a +/- EV symbol.

If your picture looks too light or too dark when you review it on your camera's monitor, you may want to reshoot it using exposure compensation. If your scene looks too bright and washed out, you need to "subtract" light, so use minus exposure compensation (-EV). If your scene looks too dark, you need to "add" light, so use plus exposure compensation (+EV). Note that underexposed images sometimes pick up a blue cast.

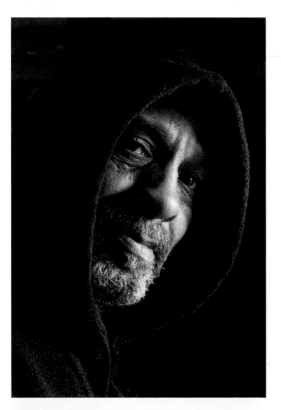

Lens Focal Length: 58mm
Aperture: f/18
Shutter Speed: 1/125 second
ISO: 100
Metering: Evaluated

A dark complexion and dark clothing can sometimes trick a camera into overexposing a photograph. A light complexioned model on a white background can sometimes be underexposed, resulting in darker, bluish pictures.

If you see that your image is too light or too dark when reviewing it on the camera's monitor, reshoot it using exposure compensation to improve the results.

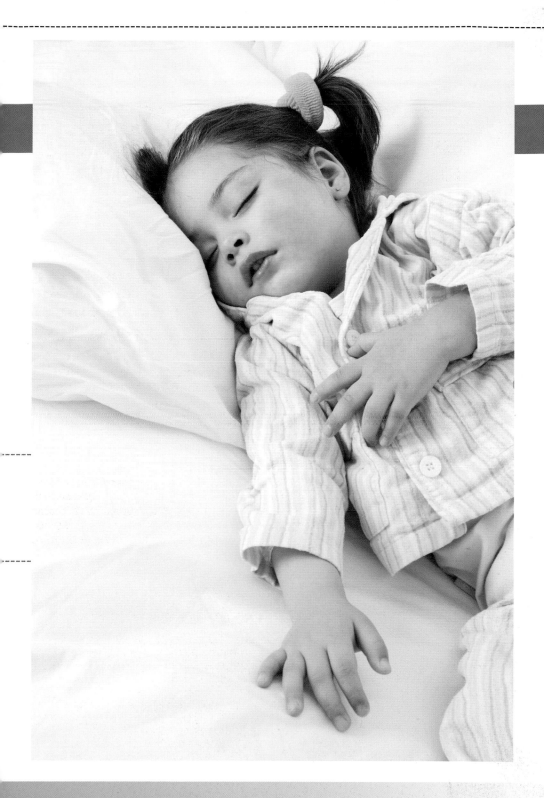

6.5 White Balance

Fine-Tuning Your Colors

Tools:

- **Color temperature (Kelvin)**
- **The color of daylight**
- **White balance controls**

Every source of light has its own particular color temperature, or hue. Visible light consists of different wavelengths with different color temperatures measured by the Kelvin (K) scale.

Our brains interpret these various colors so that, in everyday life, we barely notice the differences between, for example, direct sunlight and shaded light or tungsten light (a household light bulb). But the sensor in your camera is more objective and records these differences when making pictures.

Digital cameras have a control called white balance (WB) that can neutralize unwanted color casts in your pictures.

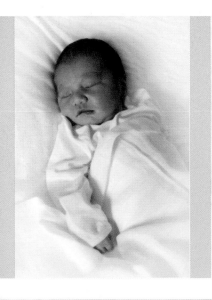 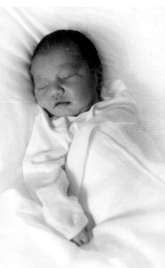

The proper color makes the far left baby portrait much more appealing than the greenish near left version.

Household lightbulbs (tungsten) and fluorescent bulbs can cause yellow or green casts. Auto White Balance (AWB) generally does a good job on most pictures. Occasionally you may want to override the camera's setting with custom settings like cloudy, fluorescent, or tungsten.

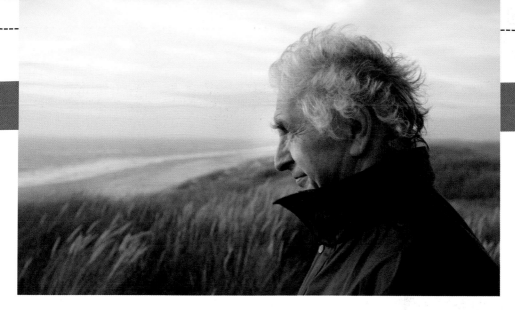

Dawn (above) and sunset (right) create very dramatic lighting, with distinct color casts. The warm tone of the late afternoon sun enhances the woman's red hair.

A car's headlight creates a dramatic feel (bottom).

Lens Focal Length: 50mm
Aperture: f/14
Shutter Speed: 1/125
ISO: 100
Metering Mode: Evaluative
White Balance: Daylight

The Color of Daylight

Daylight is considered neutral light, with a color temperature of about 5500K. Most household lamps have a much warmer tone (lower K temperature). If you take a digital picture of a white wall under tungsten lighting, the wall will have a reddish-yellow cast. Fluorescent lights can look greenish (unless they are a special daylight-balanced variety). Flash is balanced to daylight. Sunsets and late afternoon light can pick up a warm,

yellowish, or reddish tone. Overcast and
rainy days can look cooler, or bluer.

Setting the camera's white balance control for
the existing lighting conditions electronically
compensates for the color of the light source.
When the white in a scene actually appears
white, then all the other colors will be more
accurate as well (unless there are multiple
types of light present).

There are usually several choices for white
balance settings on a digital camera, includ-
ing Auto White Balance (AWB), Daylight
(commonly a sun icon), Cloudy (a cloud

Fire has a dramatic red
color to it, that contrasts
nicely with the rich blue
evening sky.

Lens: Focal Length: 30mm
Aperture: f/13
Shutter Speed: 1/25
ISO: 200
Metering: Evaluative

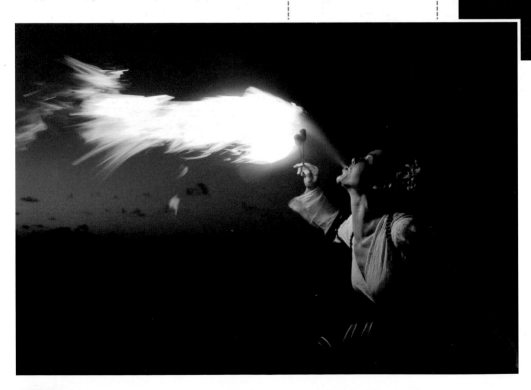

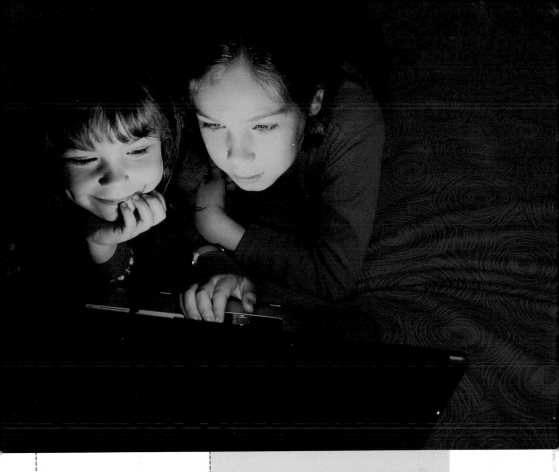

Lens Focal Length: 29mm
Aperture: f/6.7
Shutter Speed: 1/125
Exposure Compensation: -0.5
ISO: 100
Flash: Remote Gelled Red

The photographer had fun with the color of light, by illuminating the girls' faces with a blue computer screen, and the rest of the room with a gelled red flash from the side.

icon), Shade (side of a house), Tungsten (light bulb), Fluorescent (fluorescent tube), and Flash (lightning). Some cameras also include a custom, or manual, function for precisely setting WB to existing lighting conditions. Advanced cameras that offer RAW file format (see page 16) can have the color of light adjusted in afterwards in the computer with software.

Most of the time you will appreciate the way AWB adjusts for unwanted color casts. But you may also switch from AWB if you like the color of a sunset or other shooting situation, because that setting might try to process the scene to appear neutral. Setting Daylight balance will keep the warm tones, while the Tungsten setting will eliminate some of the warmth by reducing the yellow cast.

6.6 Image-Processing Software
to Improve or Alter Your Pictures

Digital photography opens up a whole new field of art once you bring your pictures onto your computer. Using image-processing software like Photoshop® or Photoshop® Elements, you can correct and enhance your pictures, or make entirely new artistic creations. The choices are limited only by the cost and availability of the software programs, and the time needed to learn and apply these tools. Refer to the software program's instruction manual or Help menu for details on how to accomplish each task.

You'll want to learn all the basics, such as cropping, brightness and contrast controls,

Tools:

- Basic controls
- Levels
- Clone or stamp
- Color modes
- Saturation
- Plug-ins

It's easy to change a color picture to black and white in the computer. When most people say, "black and white," they really mean a photo made up of shades of gray (grayscale). And, your black-and-white pictures don't need to be just gray tones! It is easy to add an antique brown, blue, or other colors to the image.

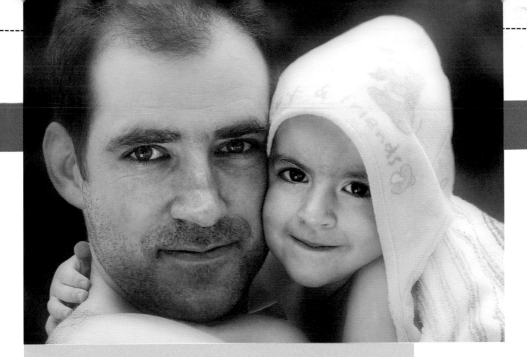

Soft effects can be added with filters and other attachments placed on the camera's lens (like the Lensbaby), or they can be added later in the computer with software tools long after the picture has been taken.

red-eye correction, color correction, and the dodge and burn tools. Some other techniques you'll want to learn are listed below.

LEVELS: Mastering Levels will quickly help you improve the look of your photos by cleaning up the highlights and shadows.

CLONE OR STAMP: This tool enables you to pick up "ink" in a pattern from one portion of the image and stamp it down elsewhere on top of unwanted elements in the picture, thereby covering them up. You can quickly remove a facial blemish in a portrait, clear out trash from behind your subject, or simplify the background. Out-of-focus backgrounds or random textured areas (such as grass or bushes) are often the easiest to work with.

COLOR MODES: Most software programs offer a set of color or picture modes that lets you instantly change the way the picture looks. Most commonly, these include changing a color picture into black and white, sepia, posterized, super-saturated, duotone, and more. Advanced "filters" can even be used to create artistic effects, such as making your photo look like it is a painting or charcoal drawing.

It can be interesting to see what your pictures look like when turned into black and whites. Check your software for a black-and-

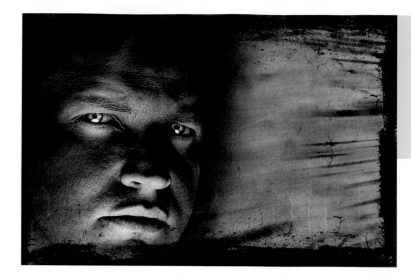

Custom frames and preset artistic effects can be applied to digital photographs in the form of "plug-ins" or special "filters" for photo-editing software.

Colors can be completely changed for artistic effect.

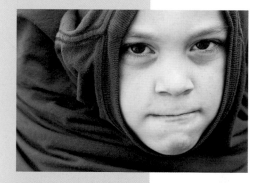

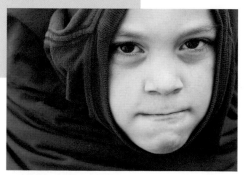

white or grayscale mode, which sometimes may be called monotone. This will discard all the colors and you'll be left with a traditional black-and-white image.

If you want to make that new black-and-white picture look antique or different in some way (see page 138), change it back to RGB mode (color). It will still look black and white in your program, but now you can use the color balance or color variation controls to add tones to the pictures. Sepia (brownish) and cyan (bluish) are popular choices.

ENHANCE OR FADE COLOR: You can also add color to make a black-and-white image look hand-colored. This can be done traditionally, by printing out the picture and then painting it with special watercolor or oil paints made for photographs. Or, if you're skilled with image-processing software, you

can desaturate the colors. If you do it selectively using layers and masks, you can create an old-time, hand-colored look. The possibilities are almost endless.

BLUR OR SOFT FOCUS: Advanced image-processing programs have special filters and controls for soft and blur effects. They can be applied to the entire image, just the highlights or shadows, or in selected areas. In the image of the father and son on page 139, softness was added to the highlights.

PLUG-INS: There are thousands of Plug-ins available for Photoshop® and other software that enable you to do quick effects, like soft focus, "speed" blurs and zoom effects, fancy frames and more.

COLLAGE & COMPLETE FANTASY: If you enjoy artistic pursuits, you may want to take a class that details advanced techniques for specific image-processing programs, such as Photoshop®. Using collaging techniques, digital paintbrushes, and advanced functions like layers, masks, and opacity, you can create some amazing portraits that combine reality with fantasy. Below is an example of what can be done.

A moth and a woman were combined for a surreal look.